PERSPECTIVES
AND
PARALLELS

Expanding Interpretive Foundations
with American Indian Curators and Writers

credits

Perspectives and Parallels:
Expanding Interpretive Foundations with American Indian Curators and Writers

This catalogue is printed in an edition of 1,250 as a culminating document of the *Perspectives and Parallels: Expanding Interpretive Foundations with American Indian Curators and Writers* program that included the exhibitions: *Mni Sota: Reflections of Time and Place* (May 29 – August 26, 2012), curated by Dyani Whitehawk Polk; *Encoded: Traditional Patterns/A contemporary Response* (September 18, 2012 – March 18, 2013), curated by John Hitchcock; *Blood Memoirs: Exploring Individuality, Memory and Culture through Portraiture* (September 13, 2013 – March 17, 2014), curated by Amber-Dawn Bear Robe; and a collaborative symposium (March 4, 2014) with UMD Department of American Indian Studies, involving UMD Associate Professor Jill Doerfler, the project curators, and writers Joanna Bigfeather and Associate Professor University of California Santa Cruz Amy Lonetree.

Catalogue design and cover artwork by Catherine Meier.

ISBN# 1-889523-39-9

Tweed Museum of Art
University of Minnesota Duluth
1201 Ordean Court
Duluth, MN 55812
218.726.8503
tma@d.umn.edu
www.d.umn.edu/tma

This project is funded in part by a grant from the National Endowment for the Arts through an Access to Artistic Excellence grant that is particularly interested in projects that extend the arts to underserved populations—those whose opportunities to experience the arts are limited by geography, ethnicity, economics, or disability. This is achieved in part through the use of Challenge America funds.

The Tweed Museum is also a fiscal 2014 recipient of an operating support grant from the Minnesota State Arts Board. This activity is also funded in part by the Arts and Cultural Heritage Fund as appropriated by the Minnesota State Legislature with money from the Legacy Amendment vote of the people of Minnesota on November 4, 2008.

This program is also supported in part by the Alice Tweed Tuohy Foundation and UMD Student Services.

ART WORKS.
arts.gov

CLEAN WATER LAND & LEGACY AMENDMENT

MINNESOTA STATE ARTS BOARD

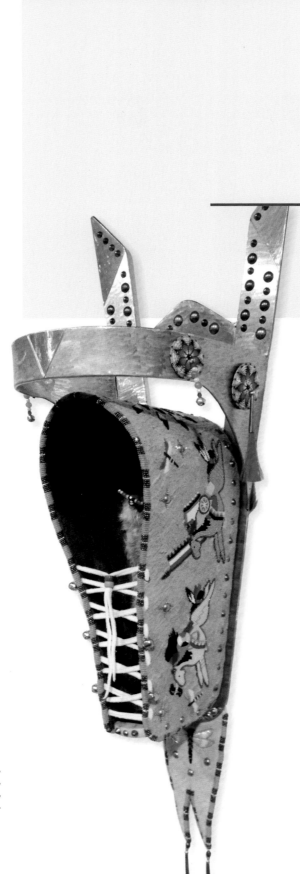

Todd Bordeaux, *21st Century Cradle Board*, 2009, stainless steel,
smoked brain-tanned moose hide, size13 cut glass beads,
horse hair, rabbit fur, wood, bells, brass beads, bells and cones,
26 x 7 x 5 inches. Collection of the Tweed Museum of Art.

contents

Origins of *Perspectives and Parallels: Expanding Interpretive Foundations*
– Ken Bloom

Fundamental to the Tweed Museum's mission is a commitment to align the content of its art collection with the interests of its various public and academic constituencies. With the acquisition of the Richard E. and Dorothy Rawlings Nelson Collection of American Indian Art in 2009, the Tweed Museum took an important step toward realizing this mission as it pertains to the region's Indigenous communities. In addition to creating expanded interpretive opportunities and exploring definitions of what constitutes the artness of Indigenous cultural objects, the Nelson Collection serves as a canonical base upon which the Tweed is building a collection of contemporary Native works. Central to the acquisition agreement with Richard Nelson was the promise that an educational collaboration between the Tweed Museum and UMD American Indian programs would follow.

The Tweed Museum of Art began as a home for great landscape painting of the 18/19th centuries. As a storyteller, the museum now acknowledges that the Indigenous populations not represented (despite being the longstanding residents of the landscape) were being relocated at the time that the historical paintings were being made and collected. Clearly, the role and meaning of these works have shifted since their creation. It stands to reason that the voices of the people made

invisible would reveal contrasting perspectives on the meanings of the art of the original Tweed collection, as well as on the cultural production represented by objects made by Native artists/artisans dating back over one hundred years.

Perspectives and Parallels: Expanding Interpretive Foundations was conceived as the first programmatic steps to address this history and to create a platform upon which Native perspectives on the Tweed Museum collection could be expressed according to the voices and visions of Native artists, scholars and curators. The assumption made in *Perspectives and Parallels* is that the Museum is a forum wherein new points of view encounter the old and that an ever-expanding range of interpretations are applied to collection objects.

Planning for the program *Perspectives and Parallels* began in 2010. Influenced by African-American artist Fred Wilson's 1992 exhibition project *Mining the Museum* at the Maryland Historical Society, Tweed invited Native American guest curators to "mine" the Museum collection and propose exhibitions. This invitation to participate was made without the assumption that our Native colleagues would necessarily focus on American Indian Arts, since the scope of the Tweed collection is broadly based. Only one requirement was expected of the curators, that each project would include at least one emerging Indigenous artist. In addition, the curators and scholar writers of the program were asked to participate in a culminating symposium to assess and respond to the program outcomes.

Coincidentally, The Native American Community Development Institute of Minneapolis, through their subsidiary All My Relations Arts, was simultaneously organizing an exhibition intended to illuminate the work of contemporary traditional artists. By collaborating with NACDI, the Tweed was honored to be the culminating site of Mni Sota's tour, which launched *Perspectives and*

Parallels. The following exhibitions ensued:
Mni Sota: Reflections of Time and Place, curated by Dyani White Hawk and Joe Horse Capture, May 29 – August 26, 2012, on ways by which Native artists of the Minnesota region embrace the contemporary while carrying traditional forms forward.

Encoded: Traditional Patterns/A Contemporary Response, curated by John Hitchcock, September 18, 2012 – March 17, 2013, five contemporary Native artists present their work in relation to select objects from The Richard E. and Dorothy Rawlings Nelson Collection of American Indian Art.

Blood Memoirs: Exploring Individuality, Memory and Culture through Portraiture, curated by Amber-Dawn Bear Robe, September 10, 2013 – March 16, 2014, an exploration of identity through the eyes of native and non-native artists.

Perspectives and Parallels: Expanding Interpretive Foundations Symposium, March 4, 2014, highlighted the curators Dyani Whitehawk, John Hitchcock, and Amber-Dawn Bear Robe, as well as the writers and scholars of the program, Joanna Bigfeather, Amy Lonetree, and moderator Jill Doerfler.

The next steps in the process of developing an ongoing American Indian arts program is for The Tweed Museum of Art to fully engage collaboratively with the UMD American Indian Studies Program, as well as the American Indian Learning Resource Center, to fulfill the interests of students, faculty and community partners. Our objectives will be to improve the Museum's interpretive capacity, to continue building a meaningful collection accessible through digitally searchable means, to regularly consult with our American Indian program partners, to work with K-12 teachers to bring Indigenous culture into the classroom, and to inspire Museum visitors. ⓣ

As a storyteller, the Beaded Mask speaks
of modern Indian Wars. In its new form,
the gas mask is emblematic of contemporary
combat because through transformation it
has supplanted a story devoid of a future with
a vivid new story possessed of possibilities.
The Beaded Mask is representative of human
duality and our ability to create beauty out
of unwilling and resistant substance.

Masks are made to fulfill a plurality
of symbolic functions. This mask was created
for many coinciding purposes, yet most
importantly was for it to be transformational.
By decorating the mask, I sought to transcend
the bleakness of its origin and to breathe new
life into its rigid man-made material, through
the real and symbolic act of layering it with the
organic life of the deer hide. In some way, the
mask has been reborn with its own power to
transform, particularly to alter the character
of the wearer's spirit.

It has been a journey for me to reclaim
an object that I initially perceived to be
cold and repugnant and to take part in its
metamorphosis; to watch it emerge with a life
of its own into a thing of beauty. By intricately
beading the mask in delicate floral designs,
the Beaded Mask is a visual contradiction to
its origins as a tool of war and a symbol of oil
dependence and environmental destruction.

– Naomi Bebo

Naomi Bebo, *Beaded Mask*, 2010, seed beads,
deer hide on Iraqi gas mask, 9½ h x 7½ w x 6½ d inches.
Collection of the Tweed Museum of Art. Exhibited in *Encoded*.

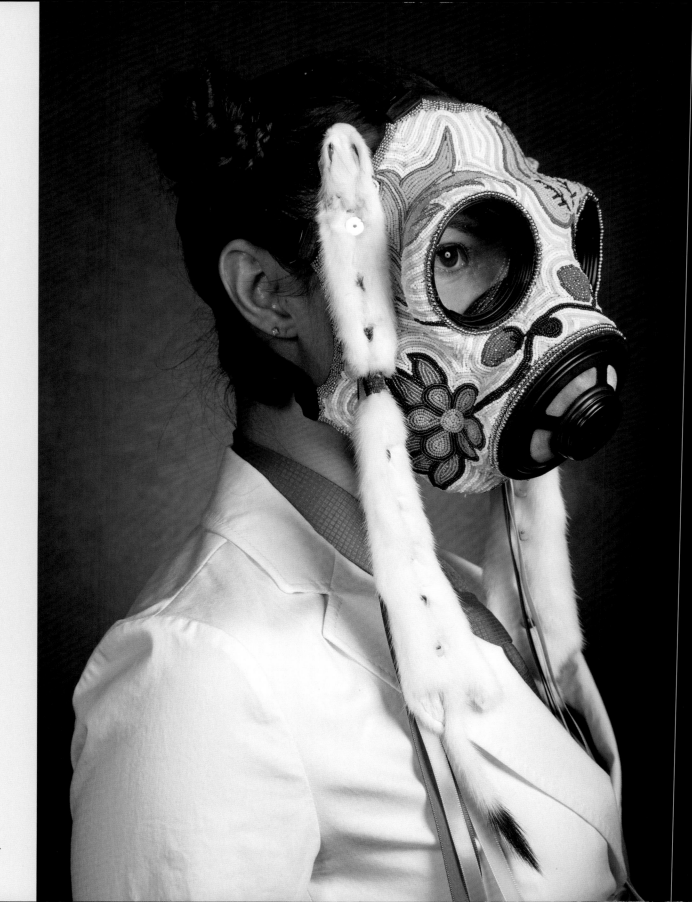

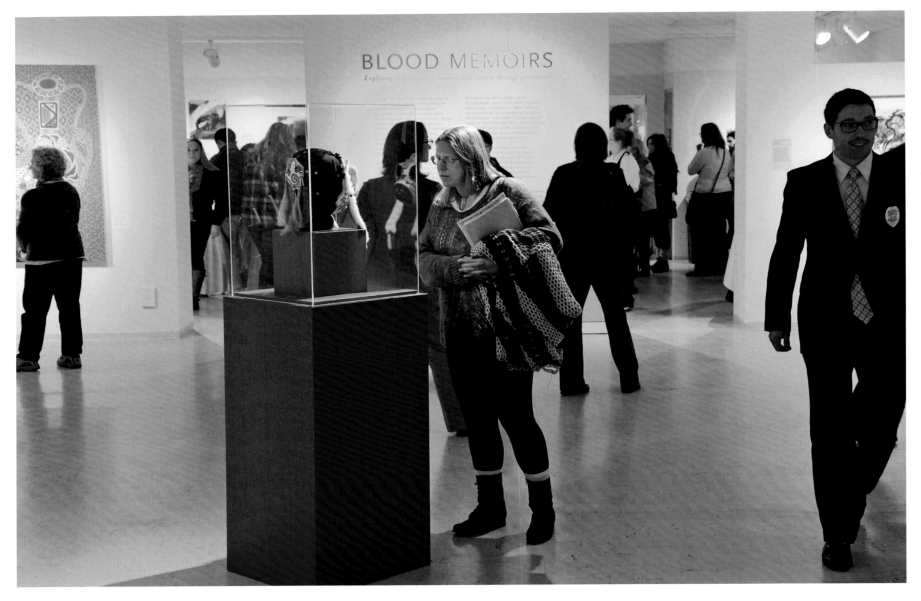

BLOOD MEMOIRS

Guest views *Beaded Mask* by Naomi Bebo in the Special Exhibitions Gallery at the opening reception for *Blood Memoirs*, October 22, 2013

What great irony that places inextricably linked to the colonization process are also the sites where the difficult aspects of our history can and must be most clearly and forcefully told. Only by doing so can we address the legacies of historically unresolved grief. But before exploring further how museums can employ decolonizing methodologies, we must first take a look at their history. Museums have played a major role in dispossessing and mis-representing Native Americans, and this has been a critical part of the identity of Euro-American museums.

Amy Lonetree, *Decolonizing Museums: Representing Native America in National and Tribal Museums*, 2012, The University of North Carolina Press, Chapel Hill.

Amy Lonetree

On the Importance of Collaboration

In 2010, I was contacted by the Tweed Museum to participate in a curatorial project focusing on their Native American collection, particularly the Richard E. and Dorothy Nelson Collection of American Indian Art. Recognizing the need to have Native people engage with this important collection, the goal was to bring artists, curators, and scholars together to develop exhibitions and essays pertaining to the Tweed's collection. It was a privilege to be asked to participate as I feel strongly that mainstream museums should collaborate with Native American communities in all aspects of museum practice, and I also recognize the critical need for Native scholars to write about the process. Collaboration between museums and Indigenous communities has now become the norm and not the exception, and it is a pleasure to work with institutions that are seeking to engage in this process.

I bring to my engagement with this project years of experience researching the changing relationship between Indigenous communities and mainstream museums. My work on this topic reached final form in my book, *Decolonizing Museums: Representing Native America in National and Tribal Museums*, published by the University of North Carolina Press in 2012. *Decolonizing Museums* focuses on the representation of Native Americans in museum exhibitions at the Smithsonian's National Museum of the American Indian and two tribal museums: the Mille Lacs Indian Museum in Minnesota and the Zibiiwing Center of Anishinabe Culture and Lifeways in Michigan. Through an analysis of the dynamic and complex process of determining exhibition content at these institutions, I explore the changing representations of Indigenous history and memory in a diverse group of museums that hold significant Native American collections. In my analysis, considerable attention is given to the recent museological shift from curator-controlled presentations of the Native American past to a more inclusive or collaborative process, one where Indigenous people are actively involved in determining exhibition content. The work critically examines the complexities of this new relationship between Native Americans and museums—both the positive outcomes as well as the challenges that remain.

My overarching argument is rooted in the belief that museums should address the legacies of historical unresolved grief that persist in our communities. Central to my analysis is exploring how museums can serve as sites of decolonization through honoring Indigenous knowledge and worldview and by discussing the hard truths of colonization in exhibitions in an effort to promote healing and understanding. Several of the sites that I examine move us forward in efforts to decolonize museums through the privileging of the Indigenous voice and perspective, serving as sites of knowledge making and remembering for our own communities and the general public, and by challenging stereotypical representations of Native people produced in the past. Further critical discussion and hard work, however, needs to occur. My goal with this project is to advance the dialogue on what a decolonizing museum practice involves and extend our understanding of the potential of museums to be "sites of conscience" and decolonization. This decolonizing project involves more than moving museums away from being elitist temples of esoteric learning and even more than moving museums toward providing forums for community engagement. A decolonizing museum practice must be in the service of speaking the hard truths of colonialism. The purpose is to generate the critical awareness that is necessary to heal from historical unresolved grief on all levels.

I believe that art museums should play a significant role in our ongoing efforts to decolonize museums, a role that involves more than just allowing Native people to consult in superficial ways on exhibition development, collections care, or educational programming. Art museums should participate fully in efforts to decolonize and indigenize museums. This involves engaging Native communities in ongoing efforts to share curatorial authority and meaningful long term collaboration. I view *Perspectives and Parallels: Expanding Interpretive Foundations* as an important step forward for the Tweed Museum as they join the ranks of those institutions that are seeking to collaborate with Indigenous communities and begin the process of long-term and mutually beneficial collaborations.

The plans for the ambitious project that the Tweed Museum embarked on in 2010 took different forms over several years as all museum projects do. While the individuals involved may have changed and earlier exhibition plans evolved, one constant remained. Throughout the collaborative process, the Tweed Museum asserted firmly the need for Native people to control the representation of their art within the exhibitions and have writers offer critical reflections on the process. It was a pleasure to work with the artists and curators who contributed to the thought-provoking and dynamic presentations at the museum, and I look forward to future conversations and publications on the collections and exhibitions as various Native American audiences engage with the museum. ⓣ

Amy Lonetree is an Associate Professor of History, University of California, Santa Cruz.

Mni Sota:
Reflections of Time and Place

Mni Sota is a program of All My Relations Arts. The mission of AMRA is to honor and strengthen relationships between contemporary American Indian artists and the living influence of preceding generations, between artists and audiences of all ethnic backgrounds, and between art and the vitality of the neighborhood.

This essay is presented here as an excerpted version from an essay of the same title that was published in Mni Sota by All My Relations Arts, Minneapolis, MN, 2012.

Dyani White Hawk &
Joe Horse Capture
Curators' Statement

There is a challenging dichotomy when discussing contemporary Native American art. One wonders if "contemporary" is a reference to style or when the artwork was created. This question is critically important to understanding Native American art within a cultural context. For the purpose of this discussion, "contemporary" is defined by when the work was created. In this broader sense of time and understanding, Native American art spans time, place, and meaning. New and innovative designs, materials, and techniques are not static in time, but move and shift with the meanings of new works. This is the premise of *Mni Sota: Reflections of Time and Place*, an exhibition that was organized by All My Relations Arts gallery which toured five

venues in Minnesota. Sponsored by the Minnesota State Arts Board, *Mni Sota* presented the works of nineteen Native artists that showcased and illustrated the ingenuity of Native American artwork as a dynamic and shifting phenomenon, returning to and influenced by creation stories as well as reflecting present-day experiential life. This exhibition, the first of its kind in Minnesota, and the All My Relations Gallery represent the continuing legacy of Native American art in the Twin Cities region.

The Minnesota State Arts Board grant category that funded this exhibit, "Folk and Traditional Arts Touring Grant," seems an obvious fit for a Native American arts organization. The label "Folk and Traditional Arts" embodies preconceived ideas of what much of the American majority imagines Native arts to be. This is no new presumption. Native artistic expressions have for centuries been expected to evoke notions of the past or tradition.

ABOVE: Bobby Wilson, *Synthetic By Nature*, 2011 (individual units: *Creation, Degeneration, Tiospaye, Growth, Wiyan*), acrylic on wood, 45 x 45 inches. Collection of the artist.

RIGHT: Guests watch *Leech Lake Reservation Youth Dance Troupe* directed by Rocky Makes Room during the opening of *Mni Sota* in the Alice Tweed Tuohy Gallery, June 12, 2012. Tipi by Todd Bordeaux, 2012, acrylic paint on canvas, horse hair, wood stakes and pine lodge poles, 16 ft. Collection of the artist.

Even among the earliest collectors, items believed to be the least influenced by European culture were viewed as the most valuable, the most "authentic." More often than not, traditional art forms have been and continue to be categorized within mainstream art arenas as craft or folk art, rarely compared with their fine art contemporaries. Yet, as a contemporary Native arts gallery, we recognize the challenges that these defining terms—"folk" and "traditional"—can pose.

The prevalent expectation that Native arts should look like or reflect preconceived notions

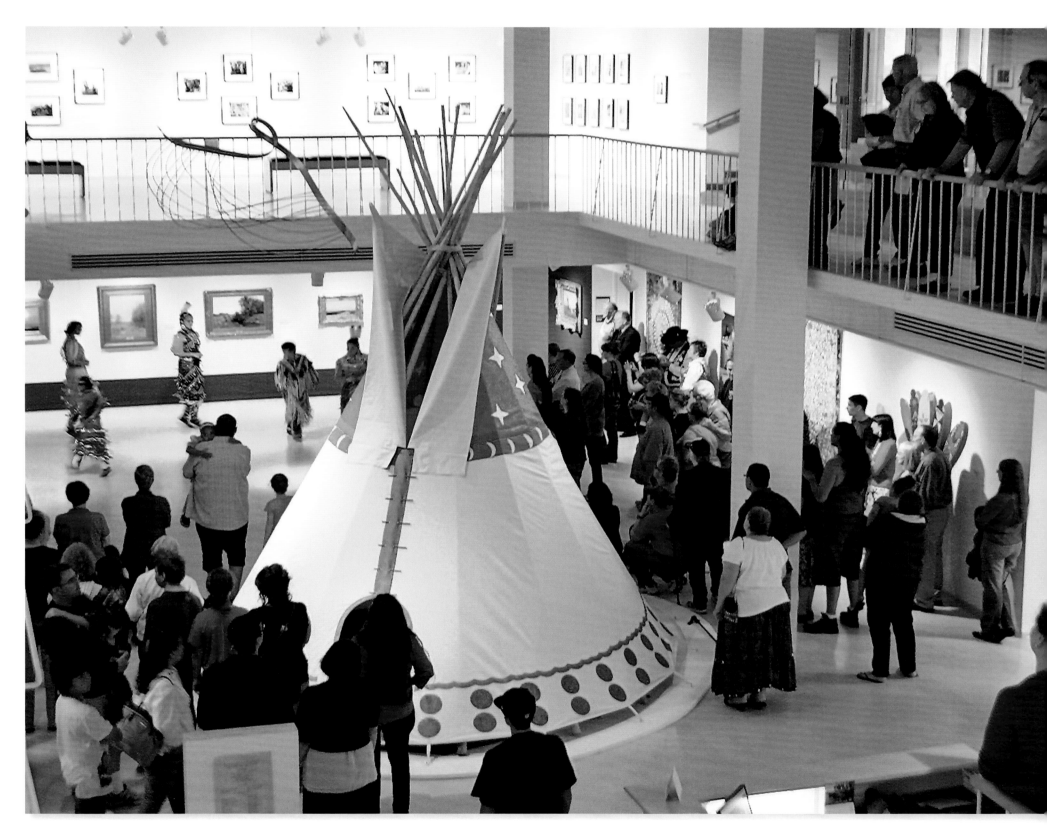

Orvilla Longfox, *Bringing in the Ponies*, 2010, porcupine quills, smoked brain-tanned buck skin and thread, 6 x 16 inches. Collection of the artist.

of historic Indian art often leave Native artists continuously struggling for greater recognition of the validity of their contemporary expressions in whatever forms they may take. If the artist's practice is based in a "traditional" fashion, utilizing techniques and tribal knowledge passed down for generations, then the artwork is judged on how truly "traditional" these works are or how genuinely rooted they are in tribal knowledge and practices. This judgment is then extended to the artist as well, who is evaluated against the same criteria, which by extension often validates or discredits the work in the eyes of many collectors and art representatives. These artists face another challenge if they wish to be exhibited outside of the Native arts scene.

The greater public does not generally understand this type of traditionally-based work and its

embedded history and symbolism. The works do not fit general conceptions of what "fine art" is supposed to look like. These Native art forms too often are seen as anthropological objects, or craft, rather than as works of fine art. They are then relegated to categories outside of "Art" with a capital A and moved into categories based on culture, craft, or geography. The Native artist whose practice is based in present-day means of execution and content faces similar scrutiny, yet with somewhat differing criteria. If the work of a contemporary Native artist does not visually or transparently convey a perceived Native aesthetic, the artist often is asked why his or her art doesn't look Indian. Too often the expectations are that the artwork must visually reflect the artist's cultural background. This is not the case with most other American artists. We do not expect all German-American artists to produce work

that reflects their German heritage.

With other contemporary Native artists who visibly utilize a Native aesthetic or whose works obviously reference a Native theme, then the questioning often shifts to whether they are using these influences in a way that is traditional. Again, the validity of their being, and by extension their art, is judged on the perceived merit of their connection to their traditional cultures. Or, on the other hand, critique is often presented in a way that discredits the validity of a culturally-based focus. Questions such as "why are your themes stuck in the past?" or "why does all your work have to be focused on Indian themes?" are asked. These expectations of what Native arts are or should not be are all symptoms of the market-imposed value systems of mainstream art institutions and academia, as well as the long-term effects of assimilation,

Ahmoo Angeconeb, *Thunderbirds and Bears*, 2011, color pencil on black paper, 15 x 42½ inches. Collection of Bockley Gallery, Minneapolis, MN.

governmental policies, and neo-colonization. When considering exhibitions such as *Mni Sota*, a new framework for evaluating Native American art needs to be established.

"Minnesota" comes from the Dakota words "mni sota" which have been translated as "clouds reflecting in water," "smoky water," or "cloudy water," all of which illustrate how our understanding of place has been defined by our surroundings. We use it here as an analogy to describe the innovative shifts of traditional arts throughout time to reflect the current landscape—our surroundings.

Contemporary Native American art is in constant motion, as it dodges and weaves through different media, places, and thoughts. The earliest documented Native American works from what we now know as Minneapolis came from the

Anishinaabe (Ojibwe) and Dakota who frequented Fort Snelling in the first half of the nineteenth century. Fort Snelling was established in the middle of Anishinaabe and Dakota Territory. Unfortunately, the only surviving works created by these ancestors were collected by non-Natives visiting the area and are now housed in museums or private collections. Based on the high quality of these surviving works, it is safe to assume that, like many tribal groups, the Anishinaabe and Dakota had a strong tradition of art production.

Like our ancestors, Native artists continue to explore. The works included in *Mni Sota* illustrate the importance and necessity of both tradition and innovation in sustaining cultural continuity. These artists hold dear the traditional teachings, worldviews, and aesthetics specific to their tribes. Yet, they also live in contemporary America and

with the results of more than a century of systematic efforts toward cultural assimilation. The negotiation of value systems this requires and the blending of differing forms of education result in a wide variety of artistic expressions. The works included in *Mni Sota: Reflections of Time and Place* provide us with examples that span the spectrum of responses to these realities as well as the artists' relationship to place, or more specifically, their indigeneity. Their responses are diverse, yet they all hold a visible link to Indigenous artistic practices and knowledge, otherwise referred to as tradition. *Mni Sota: Reflections of Time and Place*, the exhibit, established that there is little difference between "contemporary" and "historic" Native American art. Instead, each work created within its own time construct is reflective of Native cultural values and experiences, regardless of the means utilized to create these important artistic expressions. ●

Pat Kruse, *Untitled, Series: My Brother's Blanket*, 2011, birch bark, red willow and deer sinew, 31¼ x 24 inches. Collection of the artist.

Denise Lajimodiere, *Feathers*, 2012, bitten work on birch bark,
7½ x 4 inches. Collection of the Tweed Museum of Art.

Norval Morrisseau, *Untitled*,
c. 1990, ink on paper,
30 x 22½ inches.
Collection of the Tweed
Museum of Art.

Francis Yellow, *What I Learned in Boarding School* (1 of 4), 2011,
ink on paper, mixed media, 9½ x 6½ inches. Collection of Todd Bokley.

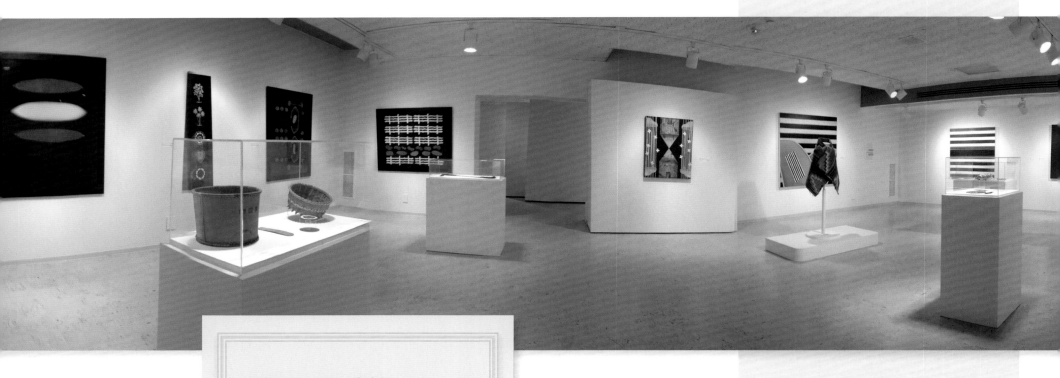

When I was a child
I would stand between mirrors
and see myself grow small,
infinite
and far away.

I didn't know the ancestors'
lives had been traded
for the vision of our faces
inside our own hands.

Excerpt (stanzas 1 and 2)
from the poem *Glass*, by Linda Hogan,
The Book of Medicines, p. 65,
Coffee House Press, 1993.

ENCODED:
Traditional Patterns /
A Contemporary Response

John Hitchcock
Curator's Statement

Encoded created an opportunity for five
contemporary artists to exhibit their work in
relation to The Richard E. and Dorothy Rawlings
Nelson Collection of American Indian Art.
The project responds to a general trend in
contemporary art and museum practice to
invite critical reflection and to view responses to
museum collections as a basis for art-making and
exhibition development. In this instance,

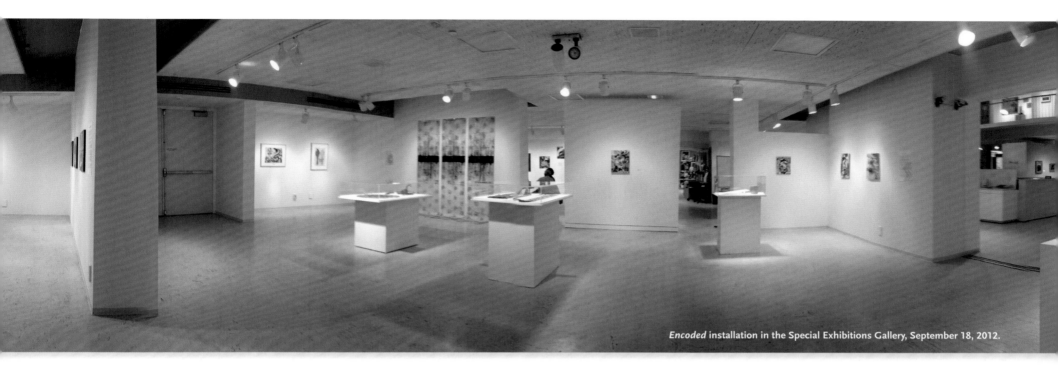

Encoded installation in the Special Exhibitions Gallery, September 18, 2012.

the tactic is one where contemporary American Indian artists can freely position and create voices for their own work and for works from a museum collection. The artists were urged to select works from the Nelson Collection to highlight design and pattern that is culturally linked to an Indigenous aesthetic related to the past, living in the present and contributing to the future.

The artists selected for *Encoded* come from a variety of geographic and tribal backgrounds: Emily Arthur (Eastern Band of the Cherokee Nation) from Florida; America Meredith (Swedish-Cherokee) living in New Mexico; Henry Payer (Winnebago from Nebraska) and Tom Jones (Ho Chunk), both living in Wisconsin; and Dyani Reynolds-White Hawk (Sicangu Lakota, German, and Welsh) from Minnesota. In their work, each artist's cultural perspective, particularly with regard to issues related to descendancy, can be discerned through reflection upon their use of pattern, color, symbolic reference, language, and character of abstraction.

Collectively, the artists of *Encoded* reveal the challenge of possessing multiple identities by addressing the political dynamics found both in their own tribal Nations and in larger art communities. Their art is a means to speak about the complexity of their worldviews by transforming their subjects into symbolic depictions within (but not limited to) formats unique to each medium of expression. Beyond the paintings, sculpture, and works on paper of this exhibition, these artists are known for having expanded their range of expression to include group projects, installation works, public art, and convergence media that are encoded with an Indigenous aesthetic. Not exclusive to the artists of this exhibition, these "conversions" are happening locally, nationally, and globally, as evidence of a contemporaneity and a power that is unique to the Native experience. 🅣

RIGHT: Henry Payer, *Westward Expansion*, 2012, paper, grass, plyboard, paper bag on insulation, 15 x 12 inches. Collection of the artist.

17

Tom Jones

In the series, I am an Indian first and an Artist second, I am investigating formally what makes a piece of artwork Native Art, even when there are no obvious visual clues or symbols that the general public can recognize. I have great respect and amazement for the work of traditional Native artists who are masters of abstraction. It is through pairings of my work and those from the Tweed collection that the audience can plainly see how modern Native art is inspired and influenced by traditional artists of the past, but at the same time need to understand that art is ever evolving and reinterpreted.

Tom Jones, *Yellow Stripe*, 2009, digital photograph, limited edition 1/5, 50 x 40 inches. Loaned by Sherry Leedy Contemporary Art, Kansas City, MO.

Henry Payer

My interest in the objects chosen from the Nelson Collection varied from their history to their aesthetic, as well as qualities they share in common with my work.

I feel that baskets hold characteristics distinct to Ho Chunk basket makers that relates to my process of hunting and gathering for materials in the use of my multimedia works.

Henry Payer, *They Got What they Came For*, 2012, paper, ration vouchers, cardboard on sheetrock, 19½ x 14 inches. Collection of the artist.

Dyani White Hawk

It is the works of my tribe and other Native art forms that move me the most. There is a sensation of awe, appreciation, excitement, and joy when I view an artwork that speaks to who I am. This is what continuously motivates me to study the works of my ancestors and fellow Native artists.

Dyani White Hawk, *Been Seeing You For Awhile Now*, 2011, acrylic and oil on canvas, 60 x 60 inches. Collection of the Tweed Museum of Art.

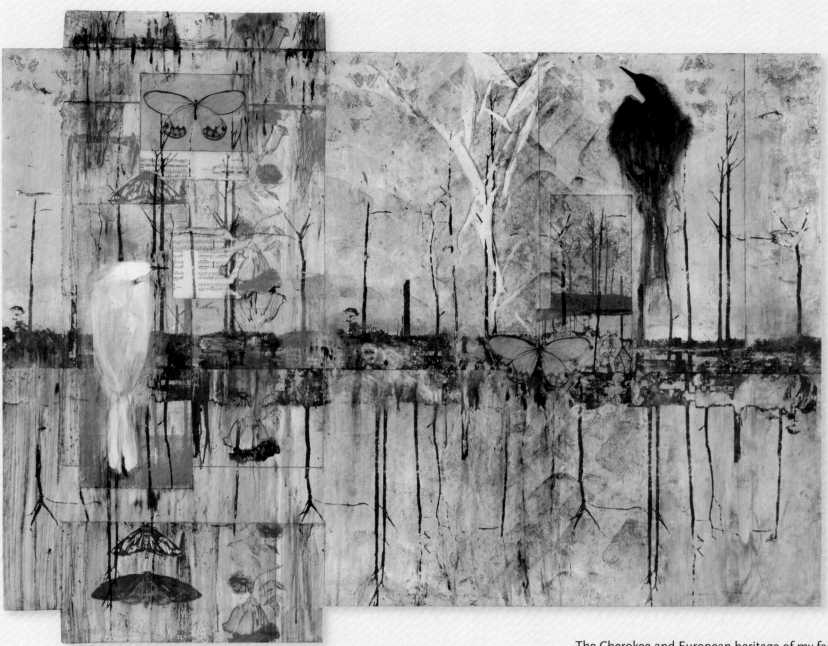

The Cherokee and European heritage of my family offer a multi-layered perspective that I mine in my work. Concern for the environment and displacement are a result of my family heritage. My work with narratives of loss holds the possibility of rebirth and transformation.

Emily Arthur

Emily Arthur, *Once Wetlands*, 2010, mixed media assemblage on BFK paper 4 x 5 feet. Collection of the Tweed Museum of Art.

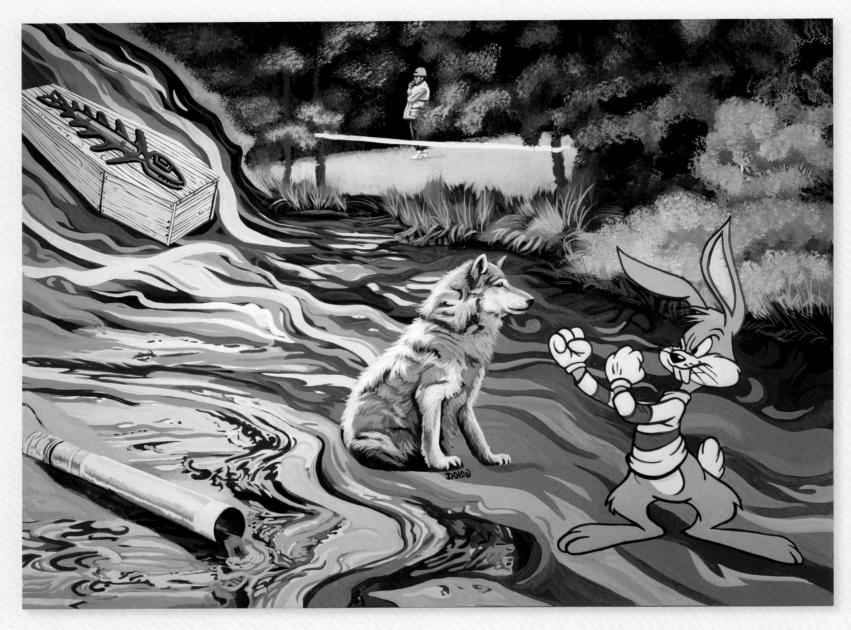

America Meredith

Many of my artworks incorporate historic and pre-contact Native artworks. *In God is Red: A Native View of Religion*, Vine Deloria, Jr. explains very eloquently how Indigenous perceptions of time are cyclical and ongoing as opposed to a linear progression. By studying Native art, I hope to understand further our cosmologies, oral history, philosophy, and our art history as our history.

America Meredith, *Trickster Rabbit and the Tar Baby*, 2012, acrylic on panel, 18 x 24 inches. Collection of the Tweed Museum of Art.

A Curator's Perspective on the Exhibit *Encoded: Traditional Patterns/A Contemporary Response*

Joanna Bigfeather

This review will examine the basic assumptions in the planning of the exhibit Encoded and the opportunities/limitations presented by the use of the Nelson Collection of American Indian Art. Ultimately these decisions have influenced the final selections and the content and meaning offered by the five artists whose work is shown here. Some additional thoughts will attempt to assess the effectiveness of the curatorial decision-making process. In other words, did the preparation place the exhibit in the current canon of Native American conversations on art-making and museum practices?

To begin with, an artist, rather than an experienced curator, was chosen to prepare this exhibit, an unusual but not uncommon choice, but one that brings a different perspective to the task. According to his own statement via interview, John Hitchcock felt this put him on equal footing with the artists, and he considered himself as a peer, rather than an academic leader. The pool of Native American curators with academic training is slowly growing, but remains small. Other decisions, both small and large, began to determine the outcomes of the presentations.

The curator was tasked with bringing the Tweed collection to a wider audience, while showcasing the work of the region. Eventually he decided to choose the Nelson Collection of Native American art and select five contemporary Native artists to

contrast and interpret their original work with respect to examples they would select.

Financial considerations influenced some of the early planning. Although originally it was thought that the artists would actually come to Duluth and see the Nelson Collection, ultimately they were asked to choose based on digital images and a copy of the catalogue *Shared Passion: The Richard E. and Dorothy Rawlings Nelson Collection of American Indian Art.* (Tweed Museum of Art, University of Minnesota Duluth. July 10-October 14, 2001). Since part of the audience for this exhibit is online, how things look in two dimensions has a huge effect on what is seen. Size, texture, depth, color, etc. are merely approximate, and at times it is really difficult to understand completely what is being viewed. Even the curator mentioned a certain frustration working from digital images and ultimately raced to the collection to get a better look.

The decision to use only the Nelson Collection, rather than the entire Tweed collection, speaks to a current conversation about Native American art in general. Most contemporary Native artists would say that they are influenced by the entire world of art, not simply an Indigenous vocabulary. That includes different techniques, other materials, and additional themes. All of the contemporary artists selected for this exhibit have gone to art schools, exposing them to a plethora of international ideas from the art world. Would allowing them to utilize the entire Tweed collection have expanded the possible audience understandings or was there a specific benefit to narrowing the choices? What does this say about the expectations of Native artists? Did the artists themselves question the parameters of the exhibit?

Another key decision was the title itself: *Encoded*. Referencing an ongoing conversation about what

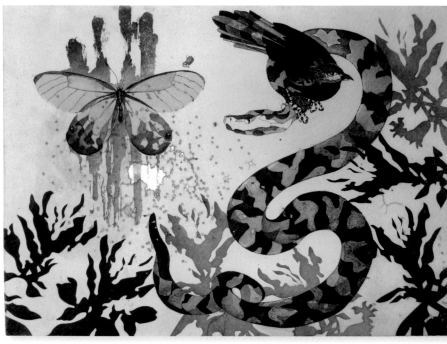

Emily Arthur, *Water Moccasin with Shadows*, 2012, sugarlift, aquatint, pochoir, chine collée, 16 x 20 inches. Collection of the Tweed Museum of Art.

material is sacred and spiritually private, encoding is how symbols are used to express ideas for a larger public, without revealing tribal secrets. It is a common practice in Native American art and can be misinterpreted widely by outsiders who do not understand at what they are looking. By choosing to use Indigenous voices both as interpreters and curators, the exhibit allowed for a more authentic reading. Also, Indigenous artists are much more sensitive to community mores and less likely to write about subjects that are taboo. Native historians tread a fine line about what they can use to advance their careers and what they must shield as culturally protected. They are much more sensitive to the long-term ramifications for their communities of speaking about confidential practices that belong to future generations. This is particularly sensitive because these ideas have been abused for decades by outsiders trying to interpret our history and culture. In the past, our traditions and rituals have limited our opportunities for scholarship, especially on the tribal lands and reservations where maintaining the basics of life, feast days, and honoring the closed ceremonies take precedence over even

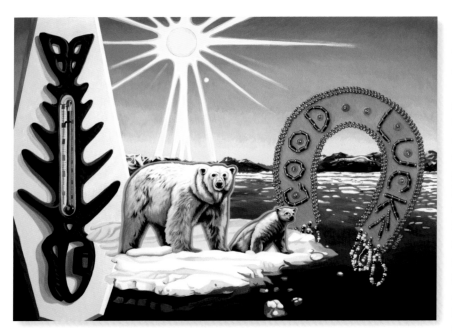

America Meredith, *Good Luck*, 2012, acrylic on panel, 18 x 24¾ inches. Collection of the artist.

the artists who participated in this exhibit, America Meredith and Henry Payer. With these two examples we can discuss how the artists worked with the mandate they were given, Meredith chose three pieces from the Nelson Collection, a birch bark book, a plastic/glass thermometer, and a good luck horseshoe. Since the collection has quite a few items produced for the tourist trade, Meredith was able to sidestep the more controversial issues of cultural privacy, while saying a lot about contemporary political themes. As she states, "tourist art," such as Iroquois whimsies, were collected by Cherokee families and were considered legitimate spins on turn-of-the-century pop culture.

Meredith, very creatively, addresses her concerns about climate change, environmental degradation, pollution, and species elimination while incorporating the objects she chose from the Nelson Collection. In her first painting *Good Luck*, the title is both funny and sad (tragicomic, she says) in an uneasy sort of way. The painting depicts the sun drenching the polar ice cap waters with two lone polar bears, a mother and her cub, drifting along on a single piece of ice. The mother looks to the viewer almost to be asking, "What are we supposed to do? You made this mess; now clean it up!" To the left we see a painting of a plastic thermometer with a fish design enclosed within. The horseshoe, which is a painting from the original leather, beadwork object, seems to say good luck to the environment, the animals, and the planet in general, as if the environment is a mess and we do not take responsibility for the condition it is in. Meredith uses the thermometer in two of her other paintings, which also reflect on the state of our environment. | CONTINUED ON PAGE 41

academic demands and schedules outside our homelands. Most of us, at one time or another, have faced conflicting demands in our professional lives. Nevertheless, this balancing act is vital as we advance our ideas about ourselves and develop our own voices.

Finally, how were the five artists ultimately selected? Given that the collection is from a specific region, is it noteworthy that most of the artists are from out of the area? Also, the Anishinaabe people are not represented, although many of the objects in the Museum are from that tribe. What we do see is that many of the artists are now recording their mixed identities more frequently. We could ask how this impacts the artists' statements and actual contemporary artists' work chosen? Did the artists themselves feel a particular connection to the works that they chose and were they comfortable with their assignments?

Given the space constraints, for the purposes of this review, I have chosen to focus on two of

Critical Engagements with Collections: Contemporary Indigenous Artists at the Tweed Museum

Amy Lonetree

It is a privilege to comment on the Tweed Museum's Exhibition, *Encoded: Traditional Pattern/A Contemporary Response,* guest curated by John Hitchcock. As a Native American museum studies scholar, I was asked to consider the exhibition development process for this show that involved Native American artists engaging with historical collections and exhibiting their contemporary works alongside historic pieces from the Tweed collection. This is an exhibition development process that many museums have pursued, and I have witnessed this process first hand over the last 20 years both as a scholar and museum professional. This is a very compelling strategy as it allows for a final product that has the potential to create dialogue and critical conversations. Most significantly, for Native people, it can help strengthen connections to "cultural art forms" currently held by museums.[1]

For the last several decades, many history and ethnographic museums (where I have spent most of my career) have developed more thematic and inquiry-driven exhibitions versus object-based exhibitions. The goal with these types of exhibitions is to move away from having the objects in their collections lead exhibition content and rather to produce shows that are more thematic and framed by key analytical questions.

Dyani White Hawk, *Torn*, 2010, acrylic, enamel, thread, pages from *Real Indians: Identity and the Survival of Native America* (Eva Marie Garroutte, 2003), 38 x 30 inches. Collection of the artist.

The themes that many of these curators pursued are influenced by direct conversations and collaborations with Native people. Contemporary issues such as the importance of family, sovereignty, treaty rights, connection to land, identity, colonialism and its ongoing effects, making a living, and survivance are just some of the topics addressed in the exhibitions that I have studied. I witnessed this transformation within the field up close and personal, and it has been paramount to my understanding of the community collaborative exhibition development process, which many museum curators have pursued as part of a new museum theory and practice.

Although the shift to more thematic-based exhibitions is viewed as an important new direction in the museum world as it highlights cultural continuance and survivance, we must not lose sight of the significance of the objects. These historic pieces are what continue to draw people to museums and, most significantly, continue to inspire Native artists. Cultural objects in museums

have a complex, multi-layered identity, a genealogy that is powerful for the viewer to consider. The somewhat hidden genealogy or the back story of objects —how they were collected, by whom, what materials were used, who made them, what was happening both in their individual lives and the broader world of their community—are powerful hidden transcripts embedded within each object. Perhaps most significantly, Native people believe that objects are living entities that embody layers of meaning and are connected to the past, present, and future of Indigenous communities. I've heard beautiful stories of Native Americans coming into a collection space and touching/ seeing/bearing witness to objects of the past and how transformative those visits are for people. One memorable engagement that I witnessed was with a group of 70 to 80-year-old elders who toured a collection space in one of the museums I've studied. These elders got to hold objects belonging to their ancestors and just being around those powerful objects brought forward a flood of memories and stories. I recall that their energy increased dramatically (already quite considerable for individuals in their 70s and 80s) as they moved through the space and spoke enthusiastically to one another about their recollections. It appeared as though just being with these objects took years off their lives and inspired meaningful conversations about their community's history, culture, and identity. As this example illustrates, the effect of bearing witness to such important collections of the past does inspire. I have seen it, and I have been profoundly moved by it.

Directly engaging with collections and allowing for Native artists to offer their perspective on the meaning of objects is an exhibition strategy that has the potential to offer great insight into the ongoing resonance of cultural art forms. The five artists invited to participate in the *Encoded* exhibition—Emily Arthur (Descendant Eastern Band of the Cherokee); America Meredith (Cherokee Nation, Swedish); Henry

Payer (Ho-Chunk); Tom Jones (Ho-Chunk); and Dyani Reynolds-White Hawk (Sicangu Lakota, German, and Welsh)—were asked to engage with the Tweed's Richard E. and Dorothy Rawlings Nelson Collection of American Indian Art and to include those objects that inspired them. The Tweed objects selected and their own artworks included in the *Encoded* exhibition are powerful visual representations providing a bridge to conversations about the Native American past and present. America Meredith reminds us that, "Our art history is our history."[2] These five artists are making and representing history through these beautiful works, and it is a pleasure to stand witness to their engagement with the Tweed's collection.

What the artists chose to display clearly reflects the diversity of their lived experiences and artistic vision. Several of the artists | CONTINUED ON PAGE 42

Tom Jones, *They Faced Their Homes to the West and Put Up Fences*, 2009, limited edition photograph, 50x40 inches. Collection of the artist.

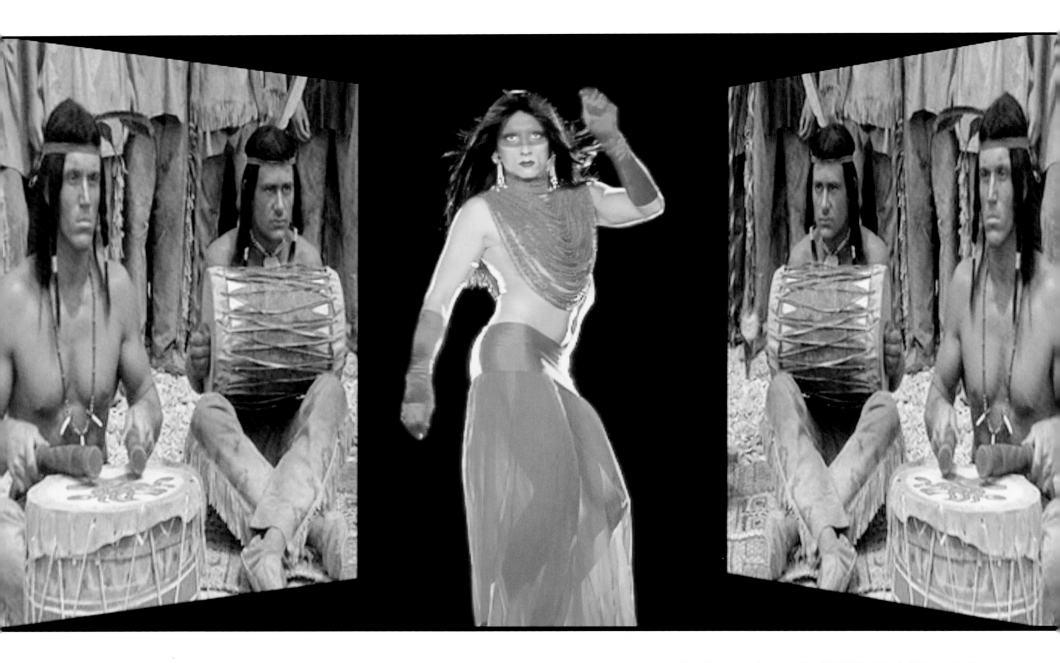

Kent Monkman, *Dance to Miss Chief*, 2010, video (still from digital betacam), 5:00 min. Collection of Paul and Mary Dailey Desmarais III.

BLOOD MEMOIRS:
Exploring Individuality, Memory, and Culture Through Portraiture

Amber-Dawn Bear Robe
Curator's Statement

Blood Memoirs looks at the contemporary vision of the North American Self by spotlighting the individuality of artists' identity and character by looking at images of portraits, which become archives of diverse memory and culture. The artists, who are in control of the image, choose how to represent themselves, mirroring identity, history, and character. Shared commonalities, as well as differences, extend beyond singularity to portray one of the many portraits of North America. The illustrated self or family, in either fictional or representational scenes, creates a public diary of memories documenting personal lives, family, history, and culture. The image of self is a shared human constituent and practice creating a mutual platform of dialogue.

Native North Americans are the foundational portrait of North America, yet the historically-assigned role of Native people as "other" saturates popular culture with images and portraits of the Indian, either as savage or a romanticized symbol. As Native scholar Vine Deloria states, "Everyone loves a Curtis Indian" (Deloria 1982). Images such as ones taken by Edward Curtis and John K. Hillers have been widely scrutinized and studied; nevertheless, those images continue to represent

a National identity indicating America anticipating European contact. Indian portraits grace the walls of public buildings and private homes and sit displayed on coffee tables compiled in large color photo books. Museums, galleries, and archives store countless images as prized historical objects that are studied by scholars, students, and others as factual documents of the past.

Rather than redundantly beating the topic of stereotyping, identity, objectification, and racism, the exhibition will demonstrate the individuality and personality of diverse Native North American people by looking at various artist portraits. Revealing the complexity of identity, *Blood Memoirs* unearths the vast scope of cultures and individuals in cultures; in other words, no one definition, meaning or image is able to identify nations.

Blood Memoirs extends into a personal space, beyond a generic grouping and romantic ideal. The show explores communal forms of belonging, identity, social and personal records that have been memorialized in contemporary art forms and contexts from the artist's perspective. Artists reveal a developing and expanding discourse as represented in forms of art expression such as painting, performance, digital media, and mediated items of material culture that promote cultural identification both by their adaptation of traditional forms into the new and by incorporating symbols of culturally-specific narratives. As Indigenous artists have introduced themselves into the mainstream, it is fitting not to backtrack by segregating the artists by curating a ghettoized exhibition. The intent is to show how artists choose to represent themselves and life. Their originality becomes influential and works to diversify the image and reality of being American and Native North American. The exploration of the artist's vision of self reveals evidence of strong identification beneficial to each of the artists' culture and community.

By looking at self-portraits, family portraits, family

Luis González Palma, *Anomino*, 1995, hand-painted gelatin silver print, collage, AP, 29 x 19 ⅝ inches. Collection Tweed Museum of Art.

scenes, images of dress, and physical attire, one can see an alternative vision, history, and humor of Native North American individuality and the vision of the artist. *Blood Memoirs* emphasizes the longevity and history of self-representation and self-expression from an intimate platform. Demonstrating personality reveals the commonalities while differences of culture

and character dig deeper than a panoramic scope. The artist is portrayed in various guises throughout the exhibition. Recurrences can be seen such as animals replacing the human form and the influence of land becoming integral to the reading; all have artistic intent to convey a personal message or story. Often the images are directly linked to a sense of place, story, emotion, and the sacred interconnection of all things. The act of remembering, for both the artists and the audience, becomes a political action of Indigenous cultural survivance and continuance, and also, for those non-Indigenous audience members, a politicized act of solidarity.

Portraits selected for *Blood Memoirs* become mirrors to the viewer, a diary of the Tweed's art collection through the lens of artists, a reflection of Minnesota and of myself as curator. The selected works parallel each other, with some directly being images of the artist while others are portraits of the artists' alter ego, community, or personality. The works become dualities that create dialogue between pairs, but also interact and engage with the exhibition as a whole. ⓣ

LEFT: Sue Johnson, *Self Portrait of the Artist as Artist Naturalist, Loplop's Sister (after Max Ernst)*, 2001, oil on linen, 38 x 50 inches. Collection Tweed Museum of Art.

ABOVE: Erik Quackenbush, *Self Portrait as a Peregrine Falcon*, 2009, acrylic on paper, 29 x 21½ inches. Collection Tweed Museum of Art.

RIGHT: Jamison Chas Banks, *UNsurgent #2*, 2013, archival inkjet print from digital source. Collection of the artist.

ABOVE: Star Wallowing Bull, *Rez Dog*, 2009, color pencil
on paper, 20 x 23 inches. Collection Tweed Museum of Art.

LEFT: Frank Big Bear, *Fawn*, 2003, color pencil on paper,
44 x 33 ¼ inches. Collection Tweed Museum of Art.

Kent Monkman, *Study for Artist and Model*, 2003, acrylic on canvas, 20 x 24 inches. Collection of the Artist.

David P. Bradley, *The Holiday*, 1986.
Lithograph on paper with hand coloring,
trial proof, 22 ½ x 30 inches.
Collection of Christine Van Lierop
and John V. Nelson.

John M. Feather, *The Don't Remember Bar*,
2008, graphite on gesso on wood,
7 ⅞ x 35 ⅞ inches.
Collection Tweed Museum of Art.

Interview with Amber-Dawn Bear Robe

Conducted by Joanna Bigfeather and Amy Lonetree
November 13, 2013

LONETREE: Please tell us about your background and why you decided to become involved with this project?

BEAR ROBE: I'm a Blackfoot from the Siksika Nation in Canada, an art historian, and a curator. While working as the director of Urban Shaman Contemporary Aboriginal Arts, I was invited to be a guest curator at the Tweed Museum of Art.

LONETREE: Could you please describe the process involved in determining which artists to include for this exhibition?

BEAR ROBE: *Blood Memoirs* is first and foremost a collections exhibition. In the beginning, I approached the Tweed's collection wanting to focus on a First Nations perspective. While going through images from the collection, I realized I was trying to fit a circle into a square. I needed to put the collection first, and let the ideas follow my discoveries. The Tweed's collection encompasses a wide spectrum of work. As I researched the many works, both online and in person, different phases, concepts, and curatorial themes arose. I realized that I didn't want to pigeonhole the show as a Native show; I wanted to look at the whole spectrum of what the Tweed had to offer. Since I began my path as an artist—I earned my undergraduate degree at The Alberta College of Art and Design, before moving quickly into arts and administration—I wanted the show to focus on the artists themselves. That is how *Blood Memoirs* came to be a portrait show. At the time of the invitation

to work with the Tweed, I was the director of Urban Shaman, the largest aboriginal art center in Canada. It was important to me that the exhibition included artists that I already had a working relationship with. Their inclusion brought them each individually to the show, but also brought an added component of myself, of my own self-portrait. I look at *Blood Memoirs* as portraiture on many levels. It is a portrait of the Tweed Museum and its largely regionally-based collection, a portrait of diverse cultures and of individual artists, but also as the exhibition's curator, it is a portrait of myself.

LONETREE: Can you elaborate a little bit more on the process of working with an art museum collection and what it means for contemporary Native artists to go back and "mine the collection?"

BEAR ROBE: The challenge is working within the boundaries of the collection. As I said, I began with ideas of mounting a Native-focused show because that's who I am as a Native curator. Though I couldn't fulfill my initial vision within the limits of the collection, those very limits became a good thing. I was forced to challenge myself, to push and broaden my perspective as a curator. The process was very different from my experience at Urban Shaman, where I was dealing with new works, installations, and performance. But the Tweed's collection was inspirational, and they were very open to pushing the boundaries with programing. *Blood Memoirs* included the performance art of Adrian Stimson and the screening of Chris Eyre's film, *Skins*. I'm happy with the outcome of the show. Its foundation is the Tweed collection, but the exhibition really builds from that.

BIGFEATHER: What are your thoughts on the importance of working with historic art museum collections when developing contemporary Native American art exhibits? Collections-based exhibitions have been critiqued in some circles for not addressing contemporary issues and some have argued that they keep Native cultures "frozen

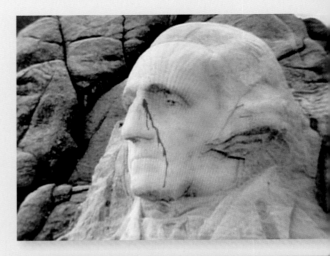

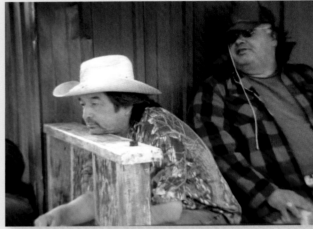

Skins

Skins depicts the bond between two conflicted brothers, Rudy and Mogie, and the effects of the destruction in Native American history on their lives today. "...This bold and cathartic drama set in place of great suffering and loss deserves to be experienced by those who cherish intimate dramas about individuals struggling against all odds to practice love, compassion, and forgiveness." Frederick and Mary Ann Brussat, *Spirituality and Practice*, 2012,
HTTP://WWW.SPIRITUALITYANDPRACTICE.COM

Stills from *Skins*, a film by Chris Eyre, 2002, First Look Media, Inc., an inspirational tale about the relationship between two Sioux Indian brothers living on the Pine Ridge Indian reservation, based on a novel by Adrian C. Louis. Pictured are Graham Greene as Mogie Yellow Lodge and Gary Farmer as Verdell Weasel Tail. Above: In tribute to Mogie's spirit, Rudy at Mount Rushmore, throws a can of paint so that it drips down the side of George Washington's face, like a stream of bloody tears.

in time" by featuring exclusively historic pieces. Would you say that this is a worthwhile strategy for curators to pursue—this returning to historic collections—or should we abandon or completely revise it?

BEAR ROBE: I don't think that historic art museum collections should necessarily be abandoned by curators who would develop contemporary Native art exhibits. The way the Tweed is working with its collections is both innovative and progressive. I was brought in purposely as an outside voice to explore the museum's own historic and contemporary curatorial expression. The works should be seen by the public. An outsider's eye brings fresh new perspectives. It allows visitors to see the collection in a different light, to hear a story differently, or engage with the material from a new angle.

LONETREE: Following up with the exhibition itself, what were the messages that you hoped the visitor would leave the museum with after viewing the show?

BEAR ROBE: The show is a contemporary vision of the North American self curated by a Native North American. The issues of colonialism and stereotypes are addressed, but not in a way that is meant to hit viewers over the head saying "Damn you, this is what's so wrong with the world." I wanted to have fun with this exhibition and for people to enjoy themselves. My aim was to create an accessible show, more than one focused on academics or politics, and to engage a larger audience with a visually fulfilling experience. My hope was that viewers would interact with the portraits, and in doing so find their own story— possibly see themselves reflected—or even envision how they would go about creating a self-portrait of their own.

BIGFEATHER: You mentioned briefly the programming around the show. Could you talk a little bit more about that, and why you decided

to include the individuals that you did, and how you hoped the programming would complement the exhibit?

BEAR ROBE: In addition to a visual art exhibition, the programing for *Blood Memoirs* included a screening of Chris Eyre's film, *Skins*, and the performance art of Adrian Stimson. I envisioned a multitude of elements for the show: performance, sculpture, two-dimensional works, video/film, and beaded masks. The film became an important and fitting component of *Blood Memoirs*, because it is a self-portrait of both a Native community and the filmmaker himself. Chris is the only Native director in the Directors Guild of America. He is [at] the frontier of Native independent film, filmography, [and] cinematography. I know he's most famous for *Smoke Signals*, but Chris would say *Skins* is one of his most Native films, if there is such a thing. The film is set in South Dakota where he was living at the time. It's an important story that people can relate to whether or not they're from the region. The territory of *Skins* is an exploration of blood ties among family—between generations—ancestral ties, ancestral blood, and ancestral memory.

The performance artist Adrian Stimson is from Siksika, like myself. Having worked with him before, he is like a brother to me. There is nothing more vulnerable than being a performance artist. You put yourself out there as an object to be looked at. This goes back to the essence of the self-portrait and the vulnerability of the self as subject. Having Chris and Adrian participate in *Blood Memoirs* was a way to bring more pieces of myself forward—to show who I am—and to expose my own vulnerabilities as the person curating the exhibition.

JOANNA: Can you talk more about what the actual performance was?

BEAR ROBE: The performance was held in the museum on the night of the opening reception. The lights were dim. Adrian came down the stairs

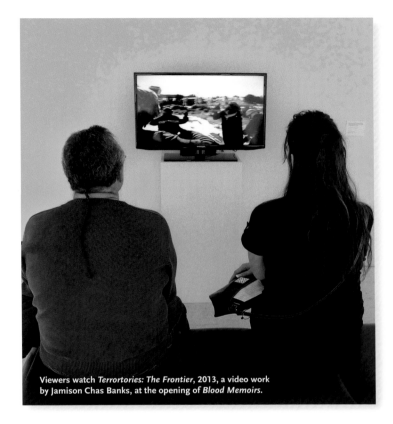

Viewers watch *Terrortories: The Frontier*, 2013, a video work by Jamison Chas Banks, at the opening of *Blood Memoirs*.

wearing makeup, a glittery cowboy hat, a buffalo robe outfit, fishnet stockings, and high-heeled cowboy boots—Buffalo Boy came out before Miss Chief. He had a whip that he was cracking, entertaining the crowd, also really playing with people's notions and ideas. He'd put together a film montage, largely clips from the Lone Ranger TV series, which he used as a backdrop to his performance. The piece referenced costumes and masks, identity and self-portraits. One thing he did was to walk through the crowd tying Lone Ranger-style masks onto people's faces, including the director of the Museum. I'm sure there must have been people who thought they were witnessing some sort of traditional tribal ceremony, which [was what] Adrian was really playing on. He was toying with people's conceptions and judgments, forcing them to think while entertaining them at the same time. Like the gallery component of *Blood Memoirs*, Adrian's performance was multi-layered. There were some very deep messages if you looked beyond the buffalo robe.

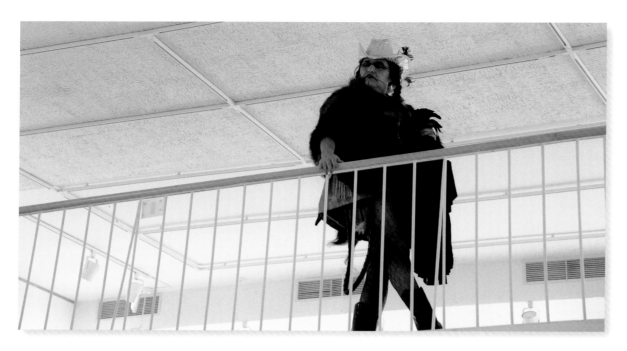

LONETREE: How did the non-Native and mixed-academic and non-academic audience react to the screening of *Skins*?

BEAR ROBE: Some of the questions were quite good, but some were larger questions that had nothing to do with the film, or were overarching as if Chris could speak for all of Native North America. But he did a good job of bringing the attention back to the film and the connections between *Blood Memoirs* and *Skins*. One interesting thing Chris discussed was the reaction of the animal group who'd been on location during the film's shooting to oversee the treatment of the spider. They were heartbroken by the homeless res dogs running around. Chris says, "Well when you take care of the people on the reserve, then those people will take care of the dogs," and he's right. I remember growing up with res dogs. Once, I tied a rope around a puppy's neck. The fleas were so bad they were literally jumping from the dog onto my shins. The whole community of Pine Ridge is poverty stricken, which is what *Skins* talks about. Res dogs are symbolic in that way.

LONETREE: You mentioned that you wanted this exhibit to be lighthearted and fun, and not just focus on colonialism and its ongoing effects. Which broader conversations in the field of Native art history informed your choices for exhibition content?

BEAR ROBE: I saw a wonderful exhibition called *Blood Memory* at the Ziibiwing Center of Anishinaabe Culture and Lifeways, an Anishinaabe tribal museum in Michigan. The experience led me to really think. The *Blood Memory* exhibition was designed as a healing space to be visited after experiencing the section of the museum that addressed the painful history of colonization. This healing space featured historic artwork that provided a moment of reflection, while making a powerful point about the role of artists in their community—that even in the darkest times, during periods of great tragedy, the artists still managed to produce works of great beauty. Though colonial policies have separated Native people from knowledge of their past, the concept of blood memory affirms the deep connections that we

have with our ancestors. It expresses our inherent right to reclaim our culture and identity. When I give presentations in the academic world about the Ziibiwing Center's concept of blood memory, white anthropologists tend to get riled. "Wait a minute, that's a western folk concept. Are you saying that tribes are subscribing to this antiquated idea about race, or is this about blood quantum?" It's frustrating not to be understood. Blood memory is about the spiritual connection that we have to our ancestors, our culture, and our land.

LONETREE: I know that this exhibit is *Blood Memoirs*, and not precisely blood memory, but were you thinking of those types of projects as you were working on this, or is your idea of *Blood Memoirs* something different?

BEAR ROBE: I wasn't specifically referencing blood memory. Blood has many different connotations, but it has specific meaning for Native North Americans. There's the idea of blood quantum and that whole political discussion of assimilation where the government decides who qualifies as Native. But Native people are part of an ancestral bloodline that runs much deeper and older. The blood that runs through our veins is attached to the land of North America. We are the land's blood. People who are not, people that immigrated here—basically all non-Native people—don't have that blood connection. It is very much the blood that ties. No portrait represents North America more than the portrait of Native North America. That's where the heart of *Blood Memoirs* lies. There's a Fritz Scholder painting in the exhibition titled *No Reservations*, which he painted using his own blood mixed with Coca-Cola. Frank Big Bear did a portrait of his daughter and Red Dog did one of his son. They hang together in the exhibition side by side like a family portrait. ⓣ

ABOVE: Adrian Stimson as *Buffalo Boy* begins his performance as s/he appears above the audience at the balcony of the Alice Tweed Tuohy Gallery, before descending the stairs to the main floor, October 22nd, 2013. AT RIGHT: *Buffalo Boy* kneels in front of a film projection holding up a Lone Ranger Mask.

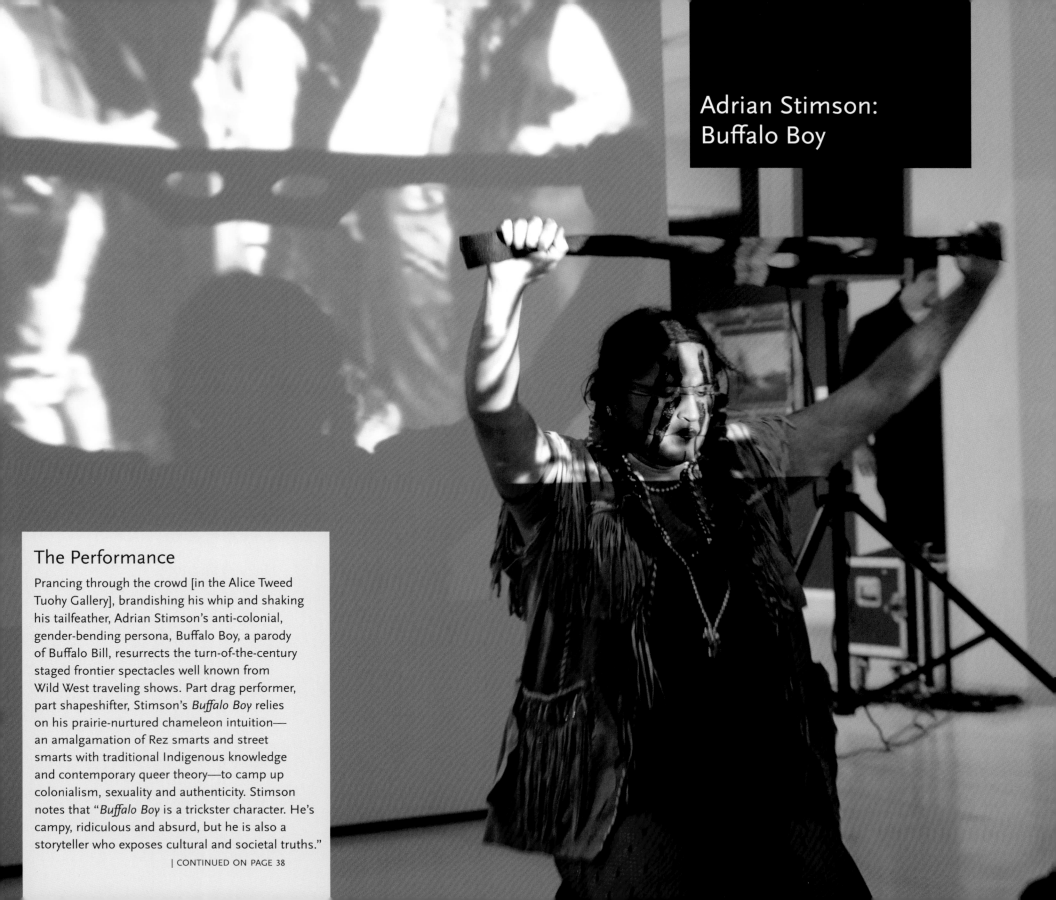

The Performance

Prancing through the crowd [in the Alice Tweed Tuohy Gallery], brandishing his whip and shaking his tailfeather, Adrian Stimson's anti-colonial, gender-bending persona, Buffalo Boy, a parody of Buffalo Bill, resurrects the turn-of-the-century staged frontier spectacles well known from Wild West traveling shows. Part drag performer, part shapeshifter, Stimson's *Buffalo Boy* relies on his prairie-nurtured chameleon intuition— an amalgamation of Rez smarts and street smarts with traditional Indigenous knowledge and contemporary queer theory—to camp up colonialism, sexuality and authenticity. Stimson notes that "*Buffalo Boy* is a trickster character. He's campy, ridiculous and absurd, but he is also a storyteller who exposes cultural and societal truths."

| CONTINUED ON PAGE 38

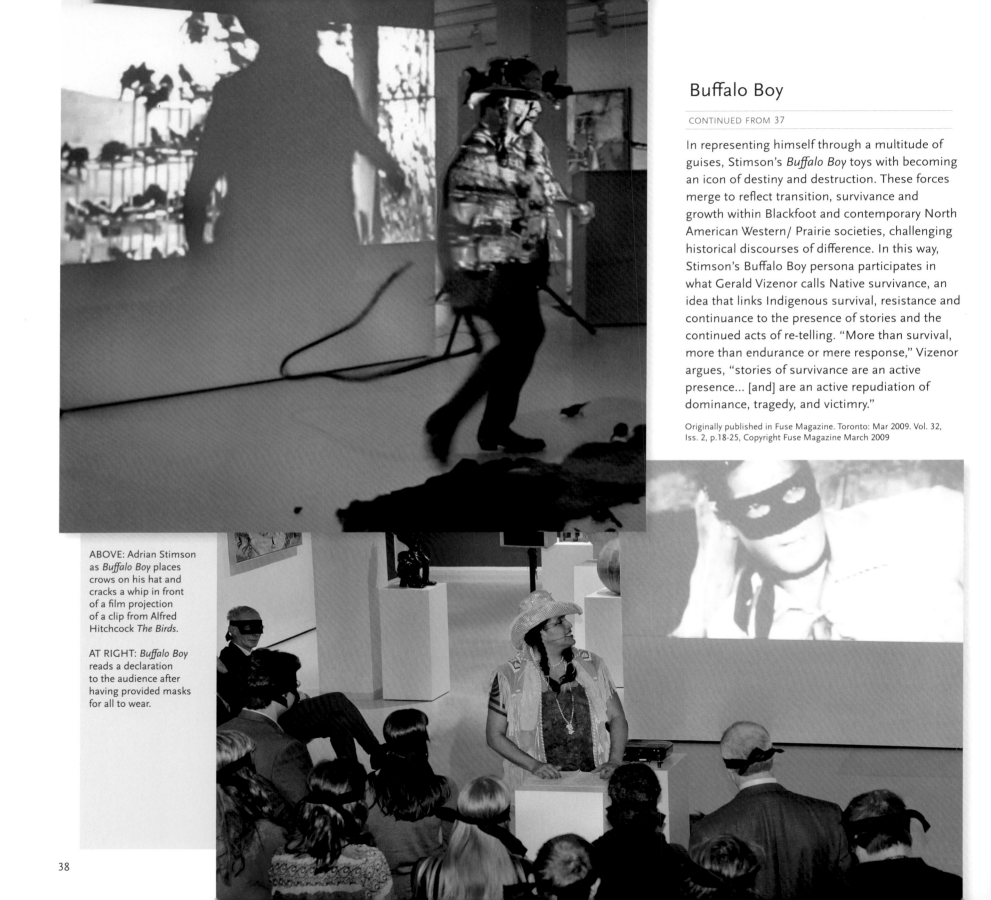

Buffalo Boy

CONTINUED FROM 37

In representing himself through a multitude of guises, Stimson's *Buffalo Boy* toys with becoming an icon of destiny and destruction. These forces merge to reflect transition, survivance and growth within Blackfoot and contemporary North American Western/ Prairie societies, challenging historical discourses of difference. In this way, Stimson's Buffalo Boy persona participates in what Gerald Vizenor calls Native survivance, an idea that links Indigenous survival, resistance and continuance to the presence of stories and the continued acts of re-telling. "More than survival, more than endurance or mere response," Vizenor argues, "stories of survivance are an active presence... [and] are an active repudiation of dominance, tragedy, and victimry."

Originally published in Fuse Magazine. Toronto: Mar 2009. Vol. 32, Iss. 2, p.18-25, Copyright Fuse Magazine March 2009

ABOVE: Adrian Stimson as *Buffalo Boy* places crows on his hat and cracks a whip in front of a film projection of a clip from Alfred Hitchcock *The Birds*.

AT RIGHT: *Buffalo Boy* reads a declaration to the audience after having provided masks for all to wear.

Perspectives and Parallels Symposium

Jill Doerfler

At the Symposium on March 4, 2014, *Perspectives and Parallels*, exhibit curators Amber-Dawn Bear Robe, John Hitchcock, and Dyani White Hawk, along with guests Joanna Bigfeather (artist and curator), and Amy Lonetree (professor and author), had an engaging and productive dialogue about contemporary Native art. I served as the moderator for the first panel session, which was an open roundtable-style panel. Among the topics discussed was the 1994 Indian Arts and Crafts Act, that is a 'truth-in-advertising' law that prohibits misrepresentation in the marketing of Native art, which sounds deceptively simple. The law requires that American Indians wishing to sell their art, as "American Indian art," be enrolled citizens of a federally-recognized Tribal nation or be specially authorized by a federally-recognized Tribal nation to claim that their art is Native-made. Panelists discussed an array of issues created by this law. While Native nations do set their own criteria for citizenship, the U.S. has had significant influence in pushing for a blood quantum requirement, and many nations follow a one-quarter Indian blood rule today. Blood quantum laws racialize Native peoples (and nations) and are highly controversial.

The concept of blood quantum is based on pseudo-scientific notions that have been thoroughly discredited and, more importantly, conflict with most Native understandings of identity. The blood quantum of an artist does not have any bearing on his or her work, but political status as a citizen of a Native nation is an important aspect of identity. Curators discussed their own practices when selecting the work of Native artists and whether they required official documentation. Panelists agreed that there are no clear answers to these complex issues of identity and recognition, but dialogues are key to working though the issues in productive ways. Current trends in Native art also were discussed. Indian Art Market in Albuquerque continues to be a center for the field and the innovations by Native artists continue to push boundaries of what is expected while remaining connected to tradition and reflecting the diversity of contemporary Native perspectives. Additionally, the vibrant field of Native art provides a means to engage the public in an array of issues that they might otherwise not be exposed to.

The Presenting Topics of the Symposium:

SUBJECT: What difference does the political influence of the art/artist that is or is not recognized by the resident nation make? • The representations of Indigenous perspectives in the forms of art, media, and literature have vastly expanded in recent years. What qualifies such representations as being authentic? • How can one determine intent and effect?

SUBJECT: What is the significance of tribal enrollment as an authenticator of messaging? • The theme of displacement is used as sub-narrative to illuminate self-identity. How does this theme work as a defining characterization of the awakening self?

SUBJECT: Can Indigenous art be recognized as art by the mainstream? • How can we characterize the reverse influence of Native arts into the mainstream? • What political dynamic exists in the use of terminology for creative object making such as: 'artwork,' 'artifact,' and 'ethnographic object'?

The Indian Arts and Crafts Act

The Indian Arts and Crafts Act of 1990 (P.L. 101-644) is a truth-in-advertising law that prohibits misrepresentation in marketing of American Indian arts and crafts products within the United States. It is illegal to display for sale or sell any art or craft product in a manner that falsely suggests it is Indian produced, an Indian product, or the product of a particular Indian or Indian Tribe or Indian arts and crafts organization, within the United States. For a violation of the Act, an individual can face civil or criminal penalties. The Act broadly applies to the marketing of arts and crafts by any person in the United States.

The US Department of the Interior explicitly states on its informational website about the Act that, "Under the Act, an Indian is defined as a member of any federally or State recognized Indian Tribe, or an individual certified as an Indian artisan by an Indian Tribe."

Delina White, *Anishinabe Woman's Handbag Purse*, 2011, size 11 cut glass beads, hand-tanned smoked hide, 15½ x 7½ inches. Collection of the Tweed Museum of Art. Exhibited in *Mni Sota*.

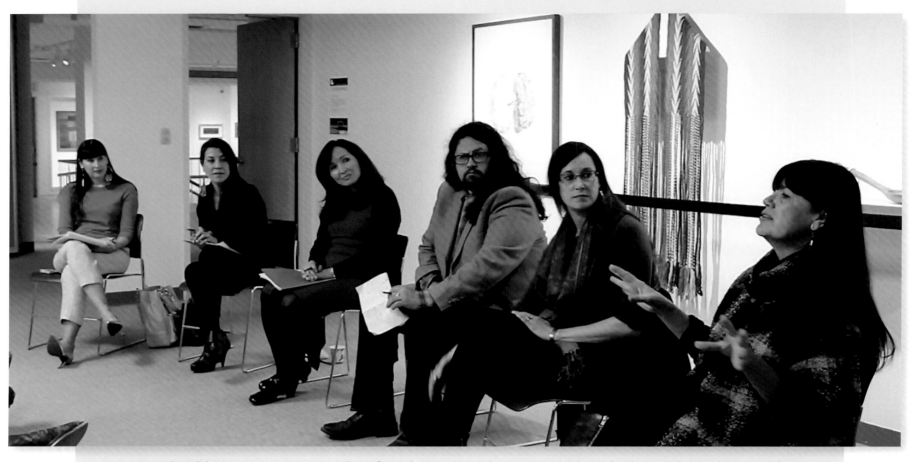

Perspectives and Parallels Symposium presenters, L-R: Jill Doerfler, Amber-Dawn Bear Robe, Amy Lonetree, John Hitchcock, Dyani White Hawk, Joanna Bigfeather.

SUBJECT: What is traditional? What is a contemporary tradition? • What characteristics can be identified that indicate an Indian voice? • Are historical representations of American Indian arts relevant? Do such projects serve to reinforce the notion of a fixed/static Indian history?

A Symposium Exchange

JILL DOERFLER:
Is the art made by artists influencing the market, or are artists making work based on what is expected to be Native Arts? Do you see changes in what is expected to be Native Art?

JOANNA BIGFEATHER:
That brings to mind Santa Fe Indian Art Market. I showed there for 10 years. It started out mainly for Pueblo people as a way for economic development. In the beginning it was just for Pueblo artists. Then they started to let out-of-the-area tribal artists in, like myself, being enrolled in the Cherokee Nation of Oklahoma. But they would let in only a few, maybe 15 or so out-of-the-area people. Everybody else was Pueblo or Navajo or Apache, those tied to the region.

I shared a booth with my cousin who does traditional pottery. What I noticed with the Indian market was, at that time 20 years ago, you had to produce a certain kind of art that people would want/expect. If you changed that at all, you were not going to be selling your work.

I wrote a paper about feeling like I was a prostitute and my gallery was my pimp because I had produced all this new work. The gallery was emphatic and said, "You can't do this during Indian Market! No experiments." But everything I was producing was experimental, because I was in school at the Institute of American Indian Arts.

Years later, when I was producing other kinds of objects—looking at ledger drawings—I was putting them on clay tablets and placing barbed wire on them to represent the internment of our warriors; many people came to my booth, and the work sold fast because there were images of tribal people with feathers and regalia. But the idea of the work was that tribal people had been imprisoned during a horrible time at Fort Marion. One lady even suggested taking the wire off the work. So, of course, I wouldn't sell it to her. But I never went on with that series because I had to take a political stand since my work was political and I couldn't just keep selling it. But it was the only time all my work sold at Indian Market. ⓣ

Joanna BigFeather

CONTINUED FROM 24

The second painting, *Trickster Rabbit and the Tar Baby*, depicts a crime scene speaking to the pollution of our rivers and streams, the endangerment of the wolf, and other disappearing or extinct species. Meredith relates this to our most recent woes, the pollution of our waters through the large sand pits in the U.S., Canada, and other countries that are extracting oil for our seemingly endless use. The thermometer appears now as a wooden coffin floating down the stream along with tainted water spilling from a pipe, most likely from a city or town nearby. Here again, her use of humor through the juxtaposition of images of the cartoon rabbit and the wooden coffin conveys the heaviness of our dilemma. I can almost hear the funeral march so often played in the cartoons of yesteryear. Perhaps Meredith suggests that Brer Rabbit (then Bugs Bunny) evolved from our trickster stories, or at the very least, continues our comic tradition.

Her final piece, *The Meek Shall Inherit the Earth,* seems to capture her themes very effectively. There is an emptiness in this landscape. The thick birch bark book seems to contain words bitten into each page, an old art form, still practiced today. With the book as the central image, it raises several questions. With the book open to the middle and with the ribbon page marker, one wonders if the rest of the book is empty or full. Are there images besides the words or symbols? Perhaps these are not words. The painting seems to say that the destiny of the environment is up to us. The petroglyph of the fish asks whether this is from the evolution of the world before humans or from a time when there are no more people but the planet has somehow survived man's inventions. Again

we see the thermometer without the plastic holder hovering above the book with the sun beaming down on the landscape of birch trees, green grass, and shrubs. All in all, Meredith, who was able to complete paintings that directly utilized the pieces from the collection, was very successful at speaking to the mission of the exhibition and produced some very original work as a result.

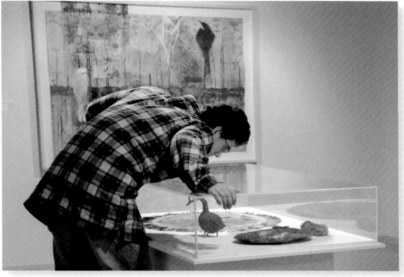

Viewers were encouraged to look for relationships between historical objects on pedestals and contemporary works. In this case, a museum visitor studies an Alaskan Hantype animal hide table cover (1890), and a Tamarak tree goose decoy made of woven branches and reeds (n.d), presented in front of the work by Emily Arthur.

Henry Payer chose items that relate to his background as a young modernist artist who uses ephemera, collage, and witty juxtapositions to reinforce his commentary on cultural appropriation, misrepresentation of Native people, and aesthetic experimentation. He selected a nineteenth century lithographic print of a Winnebago chief, a tourist novelty item which reads, "An Indian scalps his enemy and a white man skins his friend," a silver pendant, and a woven ash basket. The ephemera in particular show up in unusual ways in Payer's paintings, but the woven basket relates to his respect for the challenging craft of his ancestors.

My first thoughts looking at the work of Henry Payer were to reference the modernist paintings of Oscar Howe (1915-1983). Howe, like the sculptor Allan Houser, has influenced Native artists for over half a century. Howe's work and his advocacy led to the acceptance of abstraction within the community. However, in 1948, he was rejected by a show of Native American art at the Philbrook Museum as his work was considered too modern and he didn't follow the set rules of "traditional" Indian art. In protest he said, "Are we to be held back forever with one phase of Indian painting that is the most common way? Are we to be herded like a bunch of sheep with no right of individualism, dictated to as the Indian has always been put on the reservation and treated like a child and the White Man knows what is best for him? … [B]ut one could easily turn to become a social protest painter. I only hope the Art World will not be one more contribution to holding us in chains."

The first time I looked at Howe's work, I felt like I was at a Pow Wow watching fancy dancers, but the images were like the stopped action in a film or a cell phone video. It is easy to see the influences of Braque and Picasso, who are credited with creating the art of collage. Howe is credited with opening the door for Native artists, in particular painters, to explore and push their work to the limits, and the influence on Payer is quite apparent. When looking at Payer's work from across the room, you would think you were looking at a fancy dancer, but upon close inspection, you will see collaged together images carefully placed to tell a story of the environment, colonization, and displacement.

The work *Chip on my Shoulder* has the image of an Indian man, presumably Ho Chunk, and in the background are thousands of discarded cell phones, contributing (along with other technical equipment), pollution to our environment,

and possibly death to mankind. He has collaged a picture of both Calvary and Indians shooting, pop culture fragments of potato chip bags, a Winnebago trailer, old receipts, possible ledger entries, and other images of found objects. His rummaging through antique stores, family archives, etc., shows up in his work in startling and new ways. It is for the viewer to decide how to interpret the multiple meanings; some may be concealed from all but those with the most insider knowledge. This is where the choice of the curator becomes most important: what to tell and what to keep hidden.

Having attended two recent conferences dealing with contemporary Native art, the annual Native American Art Studies Association (NAASA) Sovereign Independent Voices in Denver this year and the Georgia O'Keefe Museum and Research Center and School of American Research-sponsored Modernist Encounters and Contemporary Inquiry: Art, Appropriations and Cultural Rights in Santa Fe, I observed that the experimentation by younger artists has been building on the efforts of their older colleagues and changing the field. The current topics of discussion at these conferences include a stronger Native curatorial voice, engagement of the tribal communities in the planning stages, interaction between Native and non-Native museums while working toward mainstreaming Native American understandings of the art world. There needs to be a realization that Native artists are actively involved with all the international mainstream art trends and are participating in those conversations, that American pop culture is a major influence and a source for Native American critique, and that Native artists are acquiring more and more professional degrees and are becoming extremely articulate critics of the national museums and the cultural world. Also under discussion are the current relationships between museums and artists, particularly the outcomes of artist residency programs.

Reflecting on the current trends in museum studies as presented at these conferences, I'd like to say a few final words about this exhibit. Ultimately, all the artists brought a thoughtful sensibility to their efforts relating to the Nelson Collection. There were enough opportunities to pair historic objects with contemporary themes in the mixed media creations presented by these five artists. The exhibit did benefit from using Native voices, showcasing work by a number of contemporary artists who are experimenting with many new forms, while still incorporating symbols and ideas from their tribal past. Perhaps in the future, using the entire Tweed collection would broaden the discussion around Native art and its meanings. Also, exhibits like this would benefit from some overall curatorial voice that brings the artists' interpretations into the wider ongoing conversations about the role of a museum in bringing Native American history, culture, and art into the mainstream of American intellectual understanding. ⓣ

Amy Lonetree

CONTINUED FROM 24

featured in the *Encoded* show tackle critical issues around identity, cultural appropriation, desecration of land and resources, and survivance in their work. These five dynamic Indigenous artists bring their considerable vision to their engagement with the collection and in the process convey how these rich historic pieces intersect with their own artistic production. Their choices demonstrate not only a great appreciation of the past but also how that past continually shapes our present and our vision for the future.

This coming to or circling back to inspiration from collections is key for many Native artists, as Dyani White Hawk explains, "A great deal of inspiration for my works is found in the artistic practices of

our ancestors. I find myself returning again and again to these ancestral works for the inspiration they bestow."[3] Inspiration for those in the *Encoded* show as described in their artist statements comes from many places including the Western art tradition (as all were trained in graduate MFA programs), as well as their respective tribal artistic traditions and the work of fellow Indigenous artists. White Hawk describes it as "cross-pollination"— this process by which Native art has influenced Western art and vice versa.[4] She blends beautifully her idea of "cross-pollination" with the stunning oil on canvas painting, *Third Phase Women's Wearing Blanket*, that recognizes the sophistication and talent of Navajo weavers and is also influenced by the Western stripe painting tradition. She is adept at reading Indigenous art with a critical eye, applying that knowledge to her own artistic practice, and with this work makes an illuminating statement on the influence of Navajo master weavers in the abstract world. Her painting can be read in multiple ways—one that is part of a Western artistic tradition while drawing inspiration from the Navajo weavers. It is work like this that embodies what the Native American artists have done continuously for generations—produced cultural art forms that draw inspiration from the artistic talents of those who have gone before them, artists who managed to create works of great beauty during some of the darkest and most painful periods in our history.

My fellow Ho-Chunks, Tom Jones and Henry Payer, are also very clear about how historical objects continue to inspire their work. Payer and Jones were invited to participate by guest curator John Hitchcock, in part due to the large number of Ho-Chunk baskets within the Nelson collection. Each tribal nation is associated with a particular art form, and the Ho-Chunk are known for their fine black ash basketry. The strips of black ash that form the baskets (with white ash used for handles) are painstakingly gathered from just the right trees and then each strip is dyed, forming a ribbon-like pattern around the baskets. Tourists

and collectors alike have long purchased Ho-Chunk baskets and still do today. Henry Payer connects his own process of "hunting and gathering" in his multimedia work with the labor intensive process Ho-Chunk basket makers have used in the past, and makes a direct connection to the work of his ancestors represented in the collection of the Tweed Museum.[5] Contemporary photographer Tom Jones also makes an explicit connection to earlier Indigenous artists in his piece, *Vertical Landscape*, inspired by an incised wood ornament and a Sioux beaded medallion that he encountered in the Tweed collection. Tom refers to traditional artists as "masters of abstraction" and this piece clearly reflects these various influences.[6]

In my interview with guest curator John Hitchcock, he stated that one of the overarching goals for this show was to create a dialogic space—a place where artists can bring out the collections, have a discussion, and inspire future conversations. It is clear that the exhibition development process pursued by the *Encoded* team reflects a way for us to re-engage with historic collections and draw new understandings through the presentation of contemporary works. The work of these artists both drawing upon and building on the great Native art that has been produced in the past conveys an important message of cultural continuance. This process of returning to historic collections and imagining new ways to engage with them is taking seriously the directive offered by scholar Ruth Phillips to re-engage with the objects in collections in the current museum age. She states the need for "re-placing objects in new kinds of interpretive contexts that draw both on the local knowledge of originating communities and on new theories of historical materiality and visuality."[7] The *Encoded* exhibit, by allowing for contemporary artists to engage directly with historic pieces and show these works alongside their own, is providing an interpretive space where we can consider the ongoing resonance of historic objects.

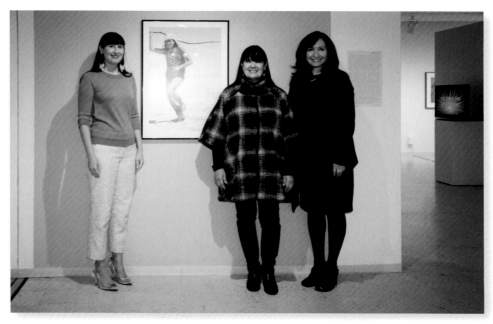

Another significant goal for the *Encoded* exhibit is to showcase contemporary works and provide the space for conversations to flourish on the meanings one can glean from them. In a recently published article, Dyani White Hawk mentions a central concern voiced by many contemporary Indigenous artists that most art museums have only a "fleeting interest" in Native art. Museums may have a show or two of Native American art, but the inclusion is only temporary and short-lived.[8] I see the Tweed Museum as taking an important step with this show to make contemporary Native American artists more than mere guests, but a part of the Museum's offerings both in exhibitions and programming. I hope this continues. By featuring the work of five contemporary Indigenous artists working in a diversity of mediums, we are reminding visitors that Native Americans are part of the modern world, drawing upon the expertise and skill of their ancestors to make works of great beauty in the present. While this may seem like an obvious reality, especially in places where Native communities exist, it is a very powerful statement when one considers the ongoing attempts to render Indigenous peoples silent and invisible within American society.

One of the important ways to challenge this invisibility and erasure is through contemporary art such as the works displayed in *Encoded* that reflect the complexities of the twenty-first century Native experience. Art scholar Nancy Marie Mithlo has stated that "our arts are significant because they offer a platform to creatively express the rage, passion, and strength of our human condition.... Given the often brutal and restrictive

manifestations of Native peoples as solely living in the past or as inauthentic shadows of their ancestors, the act of creating, reproducing, and circulating one's own stories becomes a form of cultural survival."[9] The artists featured in the *Encoded* exhibition through selection of historic objects to feature with their own works, moves us forward with our collective effort to understand the Indigenous past and present in all of its complexities, and convey the central message of cultural continuance by displaying the historic with the new. It is an exhibition strategy that I hope the Tweed and other art museums continue to pursue. ⓣ

1. John Paul Rangel uses this term, borrowed from Tatiana Lomahaftewa-Singer, when discussing what some refer to as "traditional art." He argues that this term "is a more productive way to imagine Native art beyond the familiar and ostracizing limitations of 'contemporary' and 'traditional.'" John Paul Rangel, "Moving Beyond the Expected: Representation and Presence in a Contemporary Native Arts Museum," *Wicazo Sa Review* 27, no. 1 (2012): 40.

2. America Meredith, "Encoded: Artist Statement." July 18, 2012.

3. Dyani Reynolds White-Hawk, "Encoded: Artist Statement." July 13, 2012.

4. Ibid.

5. Henry Payer, "Encoded: Artist Statement." July 18, 2012.

6. Tom Jones, "Encoded: Artist Statement." July 18, 2012.

7. Ruth B. Phillips, "Re-placing Objects: Historical Practices for the Second Museum Age," *The Canadian Historical Review* 86, no. 1, (2005): 109.

8. Dyani Reynolds-White Hawk, "Unexpected Parallels: Commonalities between Native American and Outsider Arts," *Wicazo Sa Review* 27, no. 1 (2012): 49.

9. Nancy Marie Mithlo, "Guest Editor's Introduction: Curatorial Practice and Native North American Art," *Wicazo Sa Review* 27, no. 1 (2012): 7.

Participant Bios

**AMBER-DAWN BEAR ROBE,
GUEST CURATOR, BLOOD MEMOIRS**
Amber-Dawn Bear Robe, Blackfoot from the Siksika Nation, Alberta, Canada, completed her undergraduate degree in fine arts from the Alberta College of Art and Design. She holds two Master of Arts degrees in American Indian Studies/Native North American Arts, and Art History, both from the University of Arizona, Tucson. She was the second guest curator for the *Perspectives and Parallels* Program, and curator of *Blood Memoirs: Exploring Individuality, Memory, and Culture Through Portraiture.*

Amber-Dawn is a curator, art historian, and consultant. Most recently, she organized *Fashion Heat: the Native Fashion as Art* show for the Santa Fe Museum of Contemporary Native Arts (a center of IAIA). Before moving to Santa Fe, Bear Robe was the Director/Curator of Urban Shaman: Contemporary Aboriginal Art, the largest Aboriginal artist-run center in Canada located in Winnipeg, Manitoba.

JOANNA BIGFEATHER, PROJECT WRITER
Joanna Bigfeather, Western Cherokee and Mescalero Apache, is an independent arts writer, curator, and artist. In the *Perspectives and Parallels* project, Bigfeather is writing on the exhibitions guest-curated by John Hitchcock and Amber-Dawn Bear Robe.

Bigfeather has created opportunities for American Indian artists at a variety of institutions over the past 25 years. She was the director and curator of American Indian Community House in New York City, where exhibitions addressed topics as diverse as HIV/AIDS, homelessness, and international borders. Relocating to Santa Fe, she became the first alumnae and the first woman to direct Santa Fe's Institute of American Indian Arts. In 2002, she was selected to curate *Native Views: Influences of Modern Cultures* for Artrain USA (Ann Arbor, Michigan), an exhibition that traveled by train to small American communities for three years. The recipient of a Master of Fine Arts degree from the State University of New York, Albany, and a Bachelor of Fine Arts degree from the University of California Santa Cruz, an abiding subject of Bigfeather's own art has been the Indian boarding school experience and the treatment of American Indian students during the late 1800s into the 1920s. Her art is in the collections of the Smithsonian Institution, the Brooklyn Museum, and the Heard Museum.

In *Changing Hands: Art Without Reservation* Bigfeather states, "Native artists are not unlike other artists; they need critical writing about their work, not just the Sunday feature article in the local paper. What we find, as far as contemporary Native art is concerned, is a country that is ignorant of the First People and not willing to make a change. It is my challenge to educators and writers to learn their history. This is your history, a shared American history."

JILL DOERFLER, SYMPOSIUM MODERATOR
Jill Doerfler, White Earth Anishinaabeg, is an associate professor in the Department of American Indian Studies at the University of Minnesota Duluth. She has worked on a variety of writing projects including the completion of her book, *Blood v. Family: The Struggle Over Identity and Tribal Citizenship Among the White Earth Anishinaabeg*, which examines staunch Anishinaabe resistance to racialization and the complex issues surrounding tribal citizenship and identity. In 2011, Dr. Doerfler was awarded a Faculty Fellowship from the Institute for Advanced Study at the University of Minnesota. Doerfler completed work on several projects including

Centering Anishinaabeg Studies: Understanding the World through Stories and *The White Earth Nation: Ratification of a Native Democratic Constitution*, both of which will be published in 2013.

Dr. Doerfler won the 2010 Beatrice Medicine Award for Scholarship in Native American Studies for *An Anishinaabe Tribalography: Investigating and Interweaving Conceptions of Identity during the 1910s on the White Earth Reservation* published in the American Indian Quarterly. She noted, "I am thrilled and honored to have my research recognized by such an important organization; it speaks to the importance of the work." The Native American Literature Symposium is organized by an independent group of Indigenous scholars committed to making a place where Native voices can be heard. As noted on their website, since 2002 they have "brought together some of the most influential voices in Native America to share our stories—in art, prose, poetry, film, religion, history, politics, music, philosophy, and science—from our worldview."

JOHN HITCHCOCK, GUEST CURATOR, ENCODED
John grew up in Lawton, Oklahoma, of Comanche and northern European descent, and earned his Bachelor of Fine Arts degree from Cameron University in Lawton. He also earned a Master of Fine Arts degree in printmaking and photography at Texas Tech University in Lubbock. He is currently an Associate Professor of Art at the University of Wisconsin-Madison where he teaches screen printing, digital and mixed media printmaking, and installation art. Among his many awards, John participated in the 2011 Venice Biennial, and was featured in *Epicentro: Retracing the Plains*, a collaboration with the Dirty Printmakers.

JOE D. HORSE CAPTURE, CO-CURATOR OF MNI SOTA
Joe Horse Capture is associate curator at the National Museum of the American Indian-Smithsonian Institution. Previously, he was the associate curator of Native American Art at the Minneapolis Institute of Arts for fifteen years, where he organized several projects and exhibitions including *From Our*

Ancestors: Art of the White Clay People and *Young People's Ofrendas: Expressions of Life and Remembrance*. He has written and contributed to several publications. Horse Capture is a member of the A'aninin (Gros Ventre) nation.

AMY LONETREE, PROJECT WRITER
A member of the Ho-chunk Nation of Wisconsin, Amy Lonetree is an Assistant Professor in the Department of American Studies at UC-Santa Cruz. Through interviews with guest curators and essays, Amy has shed critical light on the exhibitions in *Perspectives and Parallels*. Lonetree was co-editor with Amanda J. Cobb of The National Museum of the American Indian: *Critical Conversations* (Lincoln: University of Nebraska Press, 2008); Guest Editor of *Critical Engagements with the Smithsonian's National Museum of the American Indian*, American Indian Quarterly, Summer/Fall 2006 and a participant in Nancy Mithlo's symposium *Visiting: Conversations on Curatorial Practice and Native North American Art*, UW-Madison, 2008, *Decolonizing Museums: Representing Native America in National and Tribal Museums*, 2012, The University of North Carolina Press, Chapel Hill. She is a contributing writer in *People of the Big Voice: Photographs of Ho-Chunk Families* by Charles Van Schaick, 1879-1942, Madison: Wisconsin Historical Society Press, 2011.

DYANI WHITE HAWK, ARTIST, ENCODED, AND CO-CURATOR OF MNI SOTA
Dyani is a Sicangu Lakota and a member of the Rosebud Sioux Tribe. She earned her Master of Fine Arts degree in Studio Arts from the University of Wisconsin-Madison and is currently the Arts Project Manager at the Native American Community Development Institute in Minneapolis. In 2012, she organized the popular and instructive exhibition *Mni Sota*, which completed a five-venue tour at the Tweed Museum of Art. She was recently awarded a McKnight Visual Artist Fellowship and won the "Best of Classification" award at the Santa Fe Indian Market in 2012 in the Painting, Drawing, Graphics, and Photography class. She was also awarded first place in painting at the Northern Plains Indian Art Market. She draws from her multicultural background

and education to create paintings and mixed media works that speak to her upbringing as a Lakota woman in an urban American landscape. Her work was represented in the *Encoded* exhibition, as part of the *Perspectives and Parallels* project, and is also in the collection of the Tweed Museum of Art.

Exhibiting Artists of Mni Sota

AHMOO ANGECONEB (Canadian, Lac Seul First Nation Ojibwe, born 1955) is known for printmaking and drawing often in color on dark paper, creating a chiaroscuro effect. Angeconeb's use of Anishinaabe iconography tells personal and spiritual stories arising from figures and symbols his people have used for numerous generations. Angeconeb was trained in visual arts and printmaking at Toronto's Lakehead University and York University in Thunder Bay, Canada. His work has been widely exhibited in Europe and North America at places such as the Siida Sami Museum, Finland; Galerie Kunstreich, Berlin; and Sandia Arts, Basel. Angeconeb's work can be found in the collections of the Canadian Museum of Civilization, Hull, Quebec; McMichael Canadian Collection, Kleinburg, Ontario; Art Gallery of Nova Scotia, Halifax, Nova Scotia; Royal Ontario Museum, Toronto; Thunder Bay Art Gallery, Thunder Bay, Ontario; All My Relations Gallery Minneapolis, Minnesota and the Tweed Museum of Art.

GREG BELLANGER (American, White Earth Band of Ojibwe, born 1968) is known for his beadwork. Bellanger attended the College of Visual Arts in St. Paul for two years, graduated from the University of Wisconsin, Stout, and studied art at Fachhochschule Hildesheim in Hildesheim, Germany, on a student exchange program. His work has been exhibited at All My Relations Gallery and at the Tweed Museum of Art.

TODD BORDEAUX (American, Sicangu Lakota and Dakota, born 1968) is known for his beadwork and jewelry. Bordeaux has received numerous awards and honors for his work and was featured in a *Today's*

Ledger Artist article in *Cowboys and Indians* magazine. He has been a judge at the Eiteljorg Museum Indian Market, and won the Harrison Eiteljorg Purchase Award. Bordeaux participated in the *Changing Hands: Art Without Reservation 2* traveling exhibition and publication, which opened at the New York Museum of Art, and has been shown at All My Relations Gallery and at the Tweed Museum of Art. His work is held in the collections of the Eiteljorg Museum and the Tweed Museum of Art.

CAROL CHARGING THUNDER (American, Oohenunpa and Oglala Lakota, born 1952) is known for her beadwork. Thunder has been beading with ceramic and cut-glass beads since she was a child and learned by watching her grandmothers, aunts, and uncles in the late 1950s and early 60s. She lived in Davis, California in the 1970s where she went through the relocation program. In 1995, she moved to the Twin Cities in Minnesota. Charging Thunder has exhibited at All My Relations Gallery and the Tweed Museum of Art.

PAT KRUSE (American, Red Cliff Band and Mille Lacs Band of Ojibwe, born 1971) is known for his geometric birch bark collage tableaux sewn with deer sinew. Kruse learned to work with birch bark from his mother, Clara Kruse, and now teaches his son, Gage. He has been featured in a number of exhibitions at venues such as the Plains Art Museum, Swan Song Contemporary Arts, and Bockley Gallery. Kruse's art can be found in numerous collections including the Plains Art Museum, the Tweed Museum of Art, Mille Lacs Indian Museum, the Legendary Waters Resort and Casino, the Mayo Clinic, and the Science Museum of Minnesota.

DENISE K. LAJIMODIER (American, Turtle Mountain Band of Ojibwe, born 1951) is known for her work in birch bark biting, and specializes in dragonfly, turtle, and floral designs. Lajimodier is also a jingle-dress dancer and a published poet. She currently works as an Assistant Professor in Educational Leadership at North Dakota State University and her book, *Dragonfly Dance*, was published by Michigan State University Press. Lajimodier has exhibited at All My Relations

Gallery and the Tweed Museum of Art, which holds her work in its collection.

ORVILLA LONGFOX (American, Assiniboine Sioux, born 1956) is known for quill work which spans both traditional and contemporary patterns. Longfox was taught quilling and brain tanning by her mother Agnes Gives the Blanket Longfox. Her traditional works include pieces such as pipe bags, warrior sets, and deer hoof jingle dresses, and her contemporary works include fully quilled pictorial scenes. Longfox has exhibited at All My Relations Gallery and the Tweed Museum of Art. Her work is held in museums and private collections including the Science Museum of Minnesota, the Minneapolis Institute of Arts, the Minnesota Historical Society, the Tweed Museum of Art, the Fond du Lac Museum, Custer's Battlefield Museum of Lame Deer, and the Fort Folle Avione Museum.

MELVIN LOSH (American, Leech Lake Band of Ojibwe ca. 1952) is known for his quill and bead work. Losh learned the traditional art form of quilled birch bark boxes from master quillworker Katherine Baldwin, a member of the Ottowa Chippewa Tribe in Michigan. Losh's honors include Best-of-Show at the Bemidji State University Annual Art Expo and the Leech Lake Tribal College Art Expo. His work has been exhibited widely including at the All My Relations Gallery and the Tweed Museum of Art. His artwork can be found in private collections and museums, including the Plains Art Museum, Minnesota Historical Society, and the Leech Lake Tribe.

CHERYL MINNEMA (American, Mille Lacs Band of Ojibwe, 1973) is known for her beadwork. Minnema was taught by her mother, Mille Benjamin, and her grandmother, Lucy Clark. She is also known for her award-winning children's picture book, *Hungry Johnny*. After graduating from Nay Ah Shing Tribal School, she received her Associate of Arts Degree from Central Lakes Community College, followed by her Bachelor of Elective Studies from St. Cloud State University. Minnema's work has been exhibited at All My Relations Gallery and the Tweed Museum of Art.
WWW.CHERYLMINNEMA.COM

WANESIA SPRY MISQUADACE (American, Fond Du Lac Band of Ojibwe, 1973) is known for her work in the traditional Ojibwe practice of Birch bark biting. Misquadace is also a skilled silversmith who combines her birch bark biting designs with silver and gold to create canisters and jewelry. Her body of work also includes basketry, beadwork, and photography. Misquadace's honors include two first place ribbons at the Santa Fe Indian Art Market. Her art works have been exhibited widely in galleries from coast to coast, including All My Relations Gallery and the Tweed Museum of Art.

NORVAL MORRISSEAU (Canadian, Anishinaabe First Nations, 1932-2007) is known for his paintings depicting native folklore and is considered the founder of the Woodland Art Movement, a style emulated by many Ojibwe artists. Morrisseau was awarded the prestigious Order of Canada Medal by the Governor General of Canada for his contribution to Canadian Art. His work is held and exhibited widely in Canada and the United States including the Tweed Museum of Art and the Thunder Bay Art Gallery. He has been collected by The National Gallery of Canada and is the only First Nations Artist who has had a solo exhibition there.

SANDRA PANACHYSE (American, Canupawakpa Dakota and Mishkeegogamang Ojibwe, born 1972) is known as a celebrated beadwork artist in both her community and the pow-wow circuit. Panachyse has been creating pow-wow regalia of traditional and contemporary styles for Native American dancers for three generations. Panachyse has exhibited at All My Relations Gallery and the Tweed Museum of Art.

JOE SAVAGE (American, Fond Du Lac Band of Ojibwe, born 1954) is known for his quillwork using natural sinew and brain-tanned deerskin. Savage's work has won many awards at Native American art shows including best-of-show awards in Kansas and Arizona. Savage has exhibited his work at All My Relations Gallery and the Tweed Museum of Art, where his work is also held in collections. WWW.SAVAGEJOE.COM

CHHOLING TAHA (American, Cree First Nations, born 1948) is known for her textile work with colorful ornamentation characterized by applique, shells, buttons, bells, and beads. Taha holds a BFA and a Master of Library and Information Science. Her awards include a Best in Show at the In the Spirit contemporary art exhibit at Washington State History Museum and First Place in Textiles at the Annual Eiteljorg Indian Market. Taha has exhibited widely, and her artworks can be found in museums and corporate and private collections throughout the United States, Canada, Europe, and Japan, including the Minnesota Museum of American Art, the Eiteljorg Museum of Art, and the Tweed Museum of Art. Her first novel, *She Who Was Taken*, was published in 2012 by Silverstone Press. WWW.SHAWLLADY.COM

CECILE TAYLOR (American, Spirit Lake Dakota and Turtle Mountain Band of Ojibwe, born 1967) is known for her three-dimensional beadwork. Taylor, self-taught, draws her inspiration from the beauty she finds in nature. Her work has been exhibited at All My Relations Gallery and the Tweed Museum of Art, and can be found in local American Indian shops such as Woodland Indian Crafts and Northland Native American Products.

WANBLI KOYAKE (Francis Yellow) (American, Itazipco Lakota, born 1954) is known for his sculpture and ledger art. Koyake is a graduate of Black Hills State University, South Dakota. His honors include both the Crazy Horse and Thunderbird Foundation Scholarships. He has exhibited at All My Relations Gallery and at the Tweed Museum of Art. His works are widely collected and held in museums including the National Museum of the American Indian, the National Museum of Wildlife Art and the Tweed Museum of Art.

GWEN WESTERMAN (American, Sisseton-Wahpeton Dakota, born 1957) is known for her art quilts inspired by traditional stories. Westerman is a professor in English and Humanities at Mankato State University and the author of *Follow the Blackbirds*, a collection of poetry written in Dakota and English, published by Michigan State University Press. Her award-winning quilts have been exhibited nationally and at All My Relations Gallery and the Tweed Museum of Art.

DELINA WHITE (American, Leech Lake Band of Ojibwe, dob unavailable) is known for her traditional Anishinaabe/Ojibwe Woodland floral design beadwork, combining beads and fabric to make attire and accessories. White learned how to make patterns and

coordinate colors from her grandmother, who introduced her to beadwork at age six. White's work has been exhibited nationally and at All My Relations Gallery and the Tweed Museum of Art. Her honors include a Bush Artist Fellowship.

BOBBY WILSON (American, Sisseton-Wahpeton Dakota, born 1984) is known as a multi-media artist who blends American Indian imagery with a graffiti-inflected style. Wilson has painted dozens of murals, performed spoken word poetry across the country, and appeared in television and radio commercials. His honors include selection in the Smithsonian's National Museum of the American Indian's Artist Leadership program, which culminated in the creation of a community mural involving American Indian youth in the Twin Cities. Wilson has exhibited at All My Relations Gallery and at the Tweed Museum of Art.

Exhibiting Artists of Encoded

EMILY W. ARTHUR, Eastern Band of the Cherokee, Descendant, is an Assistant Professor at the University of Wisconsin Madison. Arthur received a Master of Fine

Arts from the Pennsylvania Academy of the Fine Arts in Philadelphia and has served as a Fellow at the Barnes Foundation for Advanced Theoretical and Critical Research, Pennsylvania. Her additional education includes the Rhode Island School of Design and the Tamarind Institute of Lithography at the University of New Mexico. Arthur is the recipient of a Florida Artist Enhancement Grant provided by the State of Florida and the National Endowment for the Arts and awarded to the Notable Women in the Arts, National Museum of Women in the Arts. Her work is included in the permanent collections of the Denver Art Museum, the Leifur Eiriksson Foundation, St. Lawrence University, University of Arizona, University of Colorado, Southern Graphics Print Council International Collection, and the Tweed Museum of Art.

Arthur has served as an International Artist in Residence in France and Japan with artists from the Diné/Navajo Nation. Arthur served in Italy at the 2011 Venice International Print Studios where she exhibited at the University of Ca'Foscari on Occasion of the Venice Biennale 54th International. International permanent collections include the nations of Iceland, Russia, Estonia, Ireland, France, Italy, the United Kingdom, India, Argentina, New Zealand, and Japan.

Joe Savage, *Quilled Belt, 1996*, porcupine quills, trade beads, buckskin/moose hide, sinew, basswood bark, natural dyes, brass, metal and cotton thread, 2½ x 43 inches. Collection of the Tweed Museum of Art. Exhibited in *Mni Sota*.

TOM JONES is an Assistant Professor of Photography at UW-Madison. He received his Master of Fine Arts in Photography and a Master of Arts in Museum Studies from Columbia College in Chicago, Illinois. Jones' photographs examine identity and geographic place with an emphasis on the experience of American Indian communities. He is interested in the way that American Indian material culture is represented through popular/commodity culture, e.g., architecture, advertising, and self-representation. He continues to work on an ongoing photographic essay on the contemporary life of his tribe, the Ho-Chunk Nation of Wisconsin. He is critically assessing the romanticized representation of Native peoples in photography through the re-examination of historic pictures taken by white photographers. This reassessment questions the assumptions about identity within the American Indian culture by non-Natives and Natives alike. Jones is a co-author of the book *People of the Big Voice, Photographs of Ho-Chunk Families by Charles Van Schaick, 1879-1943*. Jones' work is in the collections of the National Museum of the American Indian, Polaroid Corporation, Sprint Corporation, The Chazen Museum of Art, The Nerman Museum, and Microsoft.

AMERICA MEREDITH is a Swedish-Cherokee artist who blends historical styles from Native America and Europe with imagery from pop culture. Her influences range from Mississippian shell engravings, TV cartoons, and the Bacone style of painting. She is an enrolled member of the Cherokee Nation, is a member of Squirrel Ridge Ceremonial Ground in Kenwood, Oklahoma, and serves on the board of the Cherokee Arts and Humanities Council, a grassroots, independent Cherokee organization interested in serving the rural Cherokee communities of northeastern Oklahoma. The Cherokee language and syllabary figure prominently in her work, as it is the strongest visual imagery unique to her tribe. She creates pen and ink drawings, fumage, monotypes, and linoleum block printing, but her primary focus is painting—in acrylic, egg tempera, gouache, and watercolor.

America earned her MFA in painting from the San Francisco Art Institute and her Bachelor of Fine Arts from the University of Oklahoma. She has shown throughout the United States and in Canada and Europe, including the Royal Scottish Academy of Art and Design and the United Nations Headquarters. In the last 15 years, she has won numerous awards at the Heard Museum, SWAIA's Indian Market, the Cherokee Heritage Center, and other competitive shows. She was a National Museum of the American Indian Artist Fellow in 2009, won the IAIA Distinguished Alumni Award for Excellence in Contemporary Native American Arts in 2007, and was voted San Francisco Weekly's Painter of the Year in 2006. She is an independent curator and lecturer.

HENRY PAYER was born in 1986, in Sioux City, Iowa, and is an enrolled member of the Winnebago Tribe of Nebraska. A 2008 graduate of Santa Fe's Institute of American Indian Arts (IAIA) and a 2010 graduate of the University of Wisconsin Madison, Payer currently lives and works in Sun Prairie, WI. Payer's narrative compositions are bold and contemporary, filled with vibrant color. Referencing the altered landscape and European modernist models of cubism, spatial distortion, and collage; each work offers a visual narrative of symbols and appropriated voices from American consumer society that reconfigures the identity of the portrait. Henry represents the work of a new generation of American Indian artists seeking to expand the range and voice of their visual and cultural representation, while attending to forms of tradition.

Exhibiting Artists of Blood Memoirs

LYNNE ALLEN (American, Standing Rock Sioux, born 1948) is known as a printmaker whose work addresses contested spaces, domination, and struggle. Allen is the Director of the School of Visual Arts at Boston University, where she is also a Professor of Art. She is a past Professor of Art at Rutgers University and the Director of the Rutgers Center for Innovative Print and Paper. Her honors include two Fulbright Scholarships (USSR, Jordan), two Andrew W. Mellon Foundation Research Grants, a New Jersey State Council on the Arts Fellowship, and a Pennsylvania Council on the Arts Grant. Allen's prints and gravures have been exhibited widely both nationally and internationally and are included in the collections of the Whitney Museum of American Art, the Corcoran Gallery of Art, the Vesteros Kunst Museum, Sweden and the Victoria & Albert Museum, London, in addition to the Tweed Museum of Art and numerous corporate collections.
WWW.LYNNEALLEN.COM

JAMISON CHARLES (CHAS) BANKS (American, Seneca-Cayuga and Cherokee of Oklahoma, born 1978) is known as a video

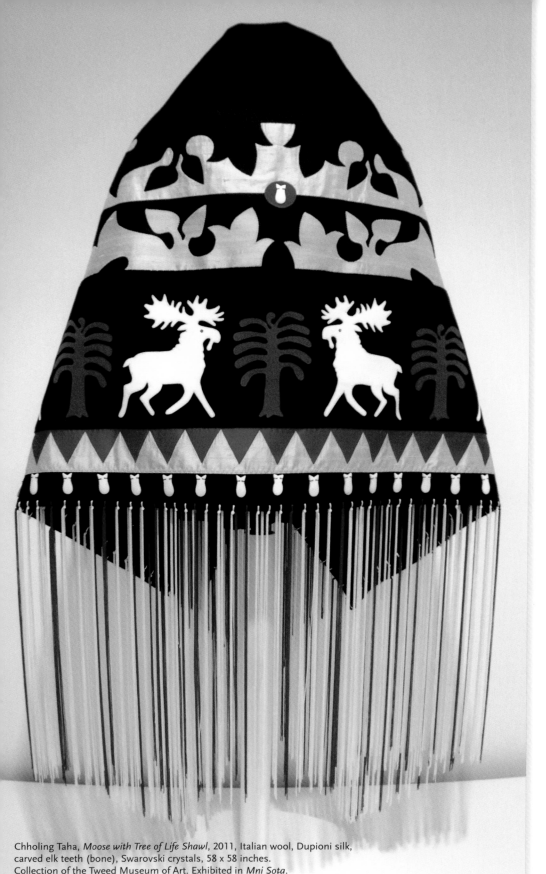

Chholing Taha, *Moose with Tree of Life Shawl*, 2011, Italian wool, Dupioni silk, carved elk teeth (bone), Swarovski crystals, 58 x 58 inches. Collection of the Tweed Museum of Art. Exhibited in *Mni Sota*.

artist. Banks also works in film, painting, performance, and installation. He received his Associate of Fine Arts and his Bachelor of Fine Arts in Studio Arts from the Institute of American Indian Arts. Banks is an adjunct professor of printmaking at IAIA, and was a Local Artist In Residence at the Museum of Contemporary Native Arts, where his work addressed the issue of peace from various perspectives. WWW.CHASBANKS.BLOGSPOT.COM

NAOMI BEBO (American, Ho-Chunk and Menominee, born 1979) is known for her beadwork. Bebo's art works fuse traditional beadwork patterns with contemporary objects as social commentary. Her works are featured in such museum collections as the Tweed Museum of Art, the National Museum of the American Indian, the Smithsonian Institution, and the Pablita Velarde Museum of Indian Women in the Arts, in publicity campaigns for the State of New Mexico, Southwest Airlines, and the Southwestern Association of American Indian Arts, and in various private collections. Bebo was admitted to the California Bar, the Arizona Bar, and the New Mexico Bar. She is a graduate of the Juris Doctor/Master of Arts program in Law and American Indian Studies at University of California, Los Angeles.

FRANK BIG BEAR (American, White Earth, Minnesota, born 1953) is known for his bright Prismacolor pencil works. His early work centers on deeply personal themes, including family and cultural identity, and on broader themes that encompass social and political issues. Big Bear was the recipient of a Jerome Foundation Fellowship, a Bush Foundation Fellowship, and a McKnight Foundation Fellowship. His work has been displayed at the Plains Art Museum, the North Dakota Museum of Art, the Bockley Gallery, the Philadelphia Museum of Art, the Institute of American Indian Arts, the Minneapolis Institute of Arts, and the Walker Art Center, among others. Big Bear's work is also held in numerous private and public collections including the Tweed Museum of Art.

DAVID P. BRADLEY (American, Ojibwe/Sioux, born 1954) is noted for his paintings, which infuse Western pop cultural icons with stereotypical Native motifs. His work also includes sculpture and printmaking. Bradley was trained at the Institute of American Indian Art and holds a BA in Fine Arts from the College of Santa Fe. His honors include a Rollin and Ella King Fellowship, and top awards at the Santa Fe Indian Market. He has exhibited widely across the nation as well as internationally. Bradley's work is held in private collections and national museum collections including the Heard Museum, The Smithsonian Institute, and the Tweed Museum of Art, with a concentration of his works in the museums of the Southwest United States.

FEDERICO CASTELLÓN (Spanish American, 1914-1971) is known for his surrealist painting, mastery of printmaking, and sculpture. Castellon's honors include two Guggenheim fellowships and membership in the National Academy of Design and the Society for American Graphic Artists. His work has been shown widely nationally and internationally including in exhibitions at the Museum of Modern Art, the Whitney Museum, the Art Institute of Chicago, and the Tweed Museum of Art.

PHILIP HOWARD F. EVERGOOD (American, 1901-1973) is known as a leading modernist of the twentieth century with styles combining abstraction and realism. His mediums include illustration, painting, printmaking, and sculpture. Sympathetic to the plight of American workers in the 1930's, Evergood's work has been noted for its unblinking social criticism. His works have been collected and exhibited internationally and are largely held in major museums across the United States, including the Tweed Museum of Art.

CHRIS EYRE (American, Cheyenne/Arapaho, born 1968) has been described as "the preeminent Native American filmmaker of his time" by People magazine. Eyre is a nationally recognized film and television director and producer who has received many awards, including both a Peabody and an Emmy. Eyre directed the highly acclaimed *Smoke Signals*, which won a coveted Sundance Audience Award and the Sundance Filmmakers Trophy. He has received a Rockefeller Foundation Intercultural Film Fellowship, an NHK/Sundance Cinema 100 Award, the

Martin Scorsese Post-Production Award, a Humanitas Prize, the Warner Brothers Post-Production Award, a United States Artists fellowship, an Independent Spirit Award, multiple First Americans in the Arts awards, and multiple Best Film awards at the American Indian Film Festival. Eyre's work for television includes three episodes of the PBS miniseries *We Shall Remain*. He also directed episodes of the NBC show *Friday Night Lights*. His latest film, *Hide Away*, was released in May 2012. WWW.CHRISEYRE.ORG

JOHN FEATHER (American, Yankton Sioux, born 1956) is a painter and illustrator whose work depicts urban native themes. Feather studied at the Institute of American Indian Arts, the Minneapolis College of Art and Design, and the University of Minnesota. His work has been exhibited in public and private venues in Duluth, MN, and Superior, WI, and is held in the collection of the Tweed Museum of Art.

VANCE GELLERT (American, born 1944) is a photographer known for his topical color series of typically environmental subjects. Gellert is the recipient of many awards, including The National Endowment for the Arts, The Jerome Foundation, the McKnight Foundation, and the Minnesota State Arts Board. Gellert has exhibited across Minnesota, as well as nationally and internationally. His work is held in private, national, and international collections and Minnesota Museums including the Minneapolis Institute of Arts and the Tweed Museum of Art. WWW.VANCEGELLERT.COM

CYNTHIA HOLMES (American, Ojibwe, born 1953) is known for her handmade Indigenous fashions that define and then cross cultural boundaries. Holmes teaches art at Fond Du Lac Tribal and Community College. She trained at the Minneapolis College of Art and Design and holds a graduate degree from the Rhode Island School of Design. Holmes' honors include a Fulbright scholarship (Brazil). Her work is featured at the Mille Lacs Indian Museum store, and is also held in public and private collections including the Tweed Museum of Art.

WING YOUNG HUIE (American, born 1955) is a photographer known for his black and white work which documents multi-cultural urban life in Minneapolis and St. Paul. His work has been honored with numerous grants and awards including the Jerome, McKnight, and Bush Foundations, the Fulbright Institute, and the Humphrey Institute of Public Affairs. Huie's photographs have been exhibited extensively in the upper Midwest as well as nationally and internationally. His work is held privately, and in national and international collections, including the Walker Art Center and the Tweed Museum of Art. WWW.WINGYOUNGHUIE.COM

SUE JOHNSON (American, born 1957) is known for her paintings and works on paper grounded in the genre of the still life and vanitas. Johnson explores the role of the artist in creating new knowledge and the history of collections and collectors, as she often works collaboratively with museums, libraries and private collections to develop site-specific exhibition projects. A Professor of Art in the Department of Art & Art History at St. Mary's College of Maryland, she earned a BFA in Painting from Syracuse University and an MFA in Painting from Columbia University. Her honors include awards from the Pollock-Krasner Foundation, the National Endowment for the Arts/Mid Atlantic Foundation Fellowship, the New Jersey State Council on the Arts, and four Individual Artist Awards from the Maryland State Arts Council. Johnson has exhibited widely in the East and Midwestern United States. Her work is in numerous private collections as well as national and international collections including the Museum of Modern Art/Franklin Furnace Archive, the Smithsonian American Art Museum Libraries, and the Tweed Museum of Art. WWW.SUEJOHNSON1.COM

ANNE LABOVITZ (American, born 1965) is known for her painting, drawing, and printmaking, which is based on portraiture. Labovitz has exhibited in the West and Midwestern United States and at international venues. Her work is held privately and can be found in the collections of the Tweed Museum of Art, The Minnesota Museum of Art, and the International Gallery of Portrait in Bosnia-Herzegovina. WWW.LABOVITZ.COM

ANNIE LIEBOVITZ (American, born 1949) is an internationally renowned photographer, known for her intimate portraits of celebrities. Liebovitz's work defined *Rolling Stone* and *Vanity Fair* magazines. Her photographs are held in private and museum collections throughout the world including the Tweed Museum of Art.

CLARA GARDNER MAIRS (American, 1878-1963) is known as a figurative painter and printmaker. Mairs received her training at the St. Paul Institute, the Pennsylvania Academy of Fine Arts, and in Paris at the Academies Julian, Colorossi and Montparnasse. Mairs' work has been exhibited at venues including the New York World's Fair, the Philadelphia Museum of Art, the Library of Congress, and the St. Paul Gallery and School of Art. Her works can be found in institutions and private collections throughout the United States, including the Tweed Museum of Art.

KENT MONKMAN (Canadian, Cree, born 1965) is known primarily for his paintings which investigate two-spirit Indigenous sexuality, but also works in performance, installation, film, and video. Monkman's work has garnered awards in film and video including the Berlinale, and the Toronto International Film Festival. He has exhibited widely within Canada at venues including the Montreal Museum of Fine Arts and the Museum of Contemporary Canadian Art, in addition to many international venues. Monkman's works are held privately and in collections including the National Gallery of Canada, the Smithsonian National Museum of the American Indian, and the Museum of London. WWW.HKENTMONKMAN.COM

NORVAL MORRISSEAU (Canadian, Anishinaabe First Nations, 1932-2007) see previous entry page: 45.

LUIS GONZÁLEZ PALMA (Guatemalan, Born 1957) is known as a photographer focused on the plight of the Indigenous Mayas and Mestizos of Guatemala, with imagery that attempts to portray the soul of a people. Palma is a recipient of the Gran Premio PhotoEspaña "Baume et Mercer." He has exhibited around the globe in both solo and group exhibitions. Three monographs

of his work have been published, including Poems of Sorrow. His photographs are held privately and in major international museum collections, including the Tweed Museum of Art. WWW.GONZALEZPALMA.COM

ERIK QUACKENBUSH (American, born 1969) is known as a painter committed to a contemporary exploration of abstract expressionism. Quackenbush holds a BFA in Studio Art from the University of Minnesota, Duluth. Quackenbush's work is in numerous public and private collections including A&L Properties Inc., the Duluth Grill, and the Tweed Museum of Art.

DIETER ROTH (Swiss, 1930–1998) also known as Dieter Rot and Diter Rot, is a Swiss artist best known for his artist's books, editioned prints, sculptures, and biodegradable artworks made of found materials, including rotting food stuffs. He won the William and Norma Copley Award, which included Marcel Duchamp, Max Ernst and Herbert Read on the jury. In the 1980s, a number of retrospectives of Roth's work in addition to large scale exhibitions of new work began to be staged throughout Europe. He represented Switzerland at the Venice Biennale and received a number of awards and prizes, including the Genevan Prix Caran d'Ache Beaux Arts, a prestigious Swiss prize.

FRITZ SCHOLDER (American, Luiseno Pueblo, 1937-2005) is known for his expressionist painting, sculpture, and printmaking. Scholder's revolutionary work broke stereotypical roles and changed the concept of "Indian artist." His work is held in private collections, at the Tweed Museum of Art, and in numerous museum collections around the world. WWW.FRITZSCHOLDER.COM

SYLVIA SCHUSTER (American, born 1944) is a master printmaker who also works in pen and ink, charcoal and pastel, whose work references classical Greek and Roman form. Shuster holds a BFA from the Rhode Island School of Design and a MFA from Cranbrook Academy of Art in Michigan. Her honors include in a Fulbright grant (Rome, Italy) and a Prix de Rome scholarship in addition to numerous fellowships within the United

States. Shuster has exhibited widely across the United States. Her work is held nationally in both public and private collections, including the Tweed Museum of Art.
WWW.SYLVIASCHUSTER.COM

W. EUGENE SMITH (American, 1918-1978) is known as the originator and master of the photo-essay. Smith worked for *Newsweek*, Ziff-Davis Publishing, and *Life Magazine*. He is best known for his World War II photojournalism, his *Loft Jazz Project* in New York, *Minamata*, a long-term photo essay of the effects of mercury poisoning in Minamata, Japan, and Family of Man, a ground-breaking exhibition at The Museum of Modern Art in New York, NY, 1955. His work is held internationally in both public and private collections, including the Tweed Museum of Art.

ADRIAN STIMSON (Canadian, Siksika Nation (Blackfoot), born 1964) is known as an interdisciplinary artist. Stimson obtained a BFA from the Alberta College of Art & Design and a MFA from the University of Saskatchewan. His work explores ideas of punishment, identity, and the re-signification of post-colonial history. Stimson has exhibited and performed widely at museums and galleries, including the Art Gallery of Alberta, La Centrale, Montreal, IPS Gallery, Montreal, and the Glenbow Museum, Calgary.
WWW.ADRIANSTIMSON.COM

SARAH STONE (American, born 1976) is known for her fantastical multi-colored paintings and drawings. Stone teaches drawing and design media at North Dakota State University. She received a BFA from the University of Minnesota, Duluth and an MFA from the University of Wisconsin, Madison. Stone has exhibited widely in the Upper Midwest and her work is held privately and in the collection of the Tweed Museum of Art.
WWW.SARAH-STONE.NET

KAY WALKINGSTICK (American, Cherokee, born 1935) is known for her painting and mixed media representations of figurative and conceptual dualities with landscapes. WalkingStick earned a BFA from Beaver College and an MFA from Pratt Institute,

and was a Professor of Art at Cornell University. Walkingstick's honors include the Krasner Award for Lifetime Achievement in addition to awards from the National Endowment for the Arts and the New York Foundation for the Arts. She has exhibited extensively across the United States and internationally. Her works are held in public and private collections, nationally and internationally, including the Metropolitan Museum of Art, the Smithsonian National Museum of the American Indian, the Heard Museum and the Tweed Museum of Art.
WWW.KAYWALKINGSTICK.COM

STAR WALLOWING BULL (American, Ojibwe/Arapaho, born 1973) is known for his drawing and printmaking depicting Native American motifs in contrast with mainstream pop culture symbols. Wallowing Bull's honors include fellowships from the Bush Foundation and the Smithsonian National Museum of the American Indian. He has exhibited at national venues including the Smithsonian National Museum of the American Indian and the Carl Gorman Museum at the University of California. His work is held in private and public collections including The British Museum, The Tweed Museum of Art, and the Weisman Art Museum.
WWW.STARWALLOWINGBULL.BLOGSPOT.COM

ANDY WARHOL (American, 1928–1987) is an American artist and a leading figure in the visual art movement known as pop art. His works explore the relationship between artistic expression, celebrity culture and advertisement that flourished by the 1960s. ⊤

Ahmoo Angeconeb, *I'm Powerful, I'm with the Almighty*, 2004, linocut on paper, ed. 2/28, 24¾ x 18½ inches. Collection of the Tweed Museum of Art. Exhibited in *Mni Sota*.

Acknowledgements

Staff and Administration
University of Minnesota Duluth Administration
Lendley (Lynn) Black, Chancellor
Lisa Erwin, Vice Chancellor for Student Life
Andrea Schokker, Executive Vice Chancellor
 for Academic Affairs
Michael P. Seymour, Vice Chancellor
 for Finance and Operations
Lucy Kragness, Chief of Staff to Chancellor
William E. Payne, Dean School of Fine Arts

Tweed Museum of Art Advisory Board
Terry Roberts, President
Bruce Hansen, Vice President
Alice O'Connor
Todd Defoe
Mary Ebert
Debra Hannu
Jane Jarnis
Robert Leff
Peggy Mason
Sharon Mollerus
Dan Shogren
Miriam Sommerness
DeeDee Widdes

Advisory Board Director's Circle
Florence Collins
Barbara Gaddie
Beverly Goldfine
Joseph Leek
Bea Levey
Robin Seiler

American Indian Advisory Committee:
Lea Carr
Carl Gawboy
Linda Grover
Wendy Savage
Ivy Vainio

Tweed Museum of Art Staff
Ken Bloom, Director
Camille Doran, Registrar
Eric Dubnicka, Preparator
Susan Hudec, Museum Educator
Steve Johnson, Guard
Kathy Sandstedt, Comptroller
Bill Shipley, Chief Docent
Joan Slack, Curator of Programs
Scott Stevens, Head of Security
Christine Strom, Communications Specialist
Greg Tiburzi, Guard

Legacy Project
Jill Decker, Collection Technician
Michael Cousino, Photographer/Image Archivist
Regina Sacchetti, Cataloger
Krista Suchy, Cataloger

Student Staff
Jaclyn Cairncross, Education Assistant
Megan Derrick, Graphic Designer
Shawnee Harkness, Registrarial Assistant
Paige Henenburg, Education Assistant
Rachel Latuff, Education Assistant
Yoo Kwon Lim, Education Assistant
Hannah Nguyen, Registrarial Assistant
Karly Nyhus, Graphic Designer
Matthew Schmitz, Videographer
GaoChy Vang, Graphic Designer

Additional Support
Monica Ares, Registrarial Assistance
Sharon Mollerus, Editorial Assistance
Peter Spooner, Grant Writing
 and Curatorial Support
Danielle Sosin, Editorial Assistance

Photographers
Ken Bloom: pp. 16-17 (above)
Mike Cousino: pp. 6, 21, 35-38, 52
Dan Dennehy: pp. 8, 10-15, 48
Sharon Mollerus: p. 43
Karley Nyhus: p. 9
David Young Wolf: p. 5

Fritz Scholder, *Untitled (Blood Skull Drawing)*, 2001-2002, blood and diet coke on paper, 6¾ x 3¾ inches. Collection Tweed Museum of Art. Exhibited in *Mni Sota*.

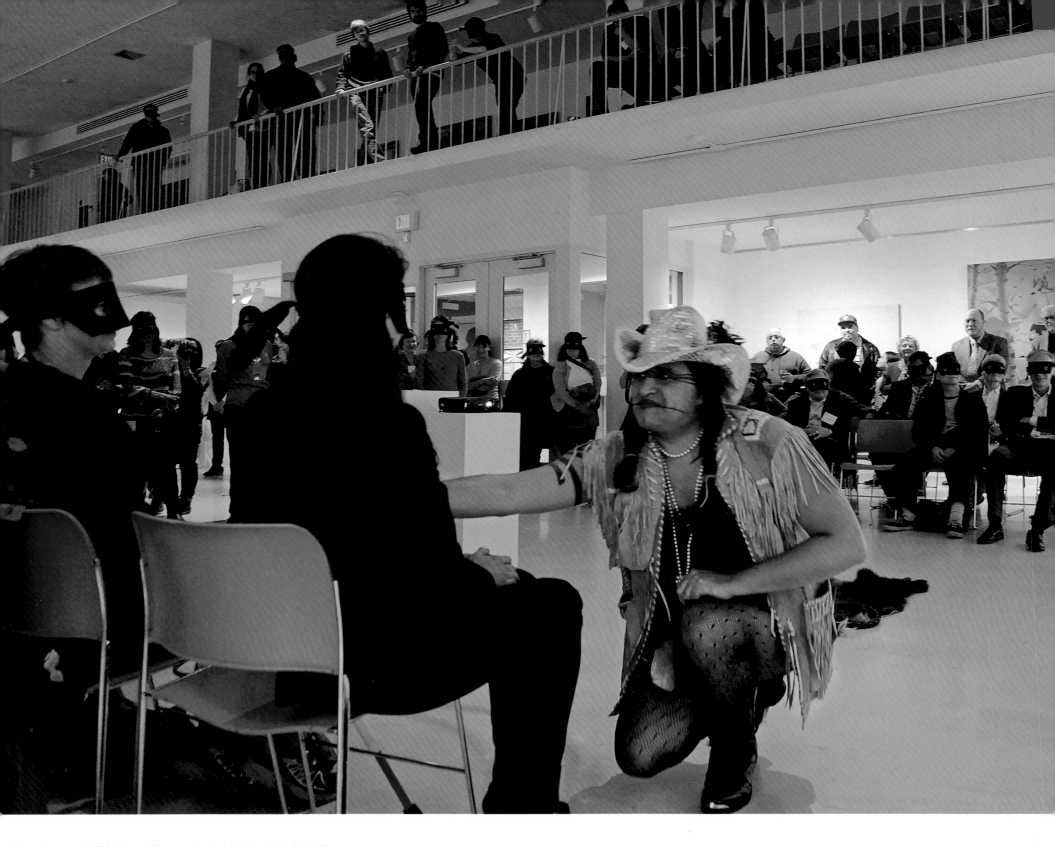

Adrian Stimson, *Buffalo Boy*, performance in the Alice Tweed Tuohy Gallery,
October 22, 2013.